AFRICAN AMERICAN ART

THE LONG STRUGGLE

CRYSTAL A. BRITTON

TODTRI

This book is dedicated to
Mary E. Britton *and* Toni Cade Bambara

Many thanks to
Jessie Hemmans, Corrine Jennings, Grace Williams,
Thomas Heath, Shirley Poole, Malika Adero, *and* Cynthia Sternau

This book was designed and produced by
TODTRI Book Publishers
P.O. Box 572, New York, NY 10116-0572
FAX : (212) 695-6984
e-mail : todtri@mindspring.com

Printed and bound in Singapore

ISBN 1-880908-72-7

Visit us on the web!
www.todtri.com

Author: Crystal A. Britton

Publisher: Robert M. Tod
Editorial Director: Elizabeth Loonan
Book Designer: Mark Weinberg
Production Coordinator: Heather Weigel
Senior Editor: Edward Douglas
Project Editor: Cynthia Sternau
Assistant Editor: Linda Greer
Picture Reseacher: Laura Wyss
Desktop Associate: Paul Kachur
Typesetting: Command-O, NYC

PICTURE CREDITS

Ackland Art Museum, The University of North Carolina at Chapel Hill 52
Amalia Amaki 116
Emma Amos 86, 90, 113
Benny Andrews 78
Atwater Kent Museum of Philadelphia, Pennsylvania 27
Radcliff Bailey 115
Xenobia Bailey 97
Bernstein Associates, Mt. Vernon, New York 110–111
Camille Billops 103
Bob Blackburn 68
Betty Blayton-Taylor 122
Mary Boone Gallery, New York 104–105
The Boston Atheneum, Massachusetts 26, 37
James Andrew Brown 118
Carol Byard 85
The Cincinnati Art Museum, Ohio 24–25
Clark Atlanta University Collection of Afro-American Art, Atlanta, Georgia 34, 46
Dallas Museum of Fine Arts, Texas 84, 91
Mel Edwards 77
Evans-Tibbs Collection, Washington, D.C. 22, 55, 56–57, 61
Gilbert Fletcher 123
Michelle Godwin 125
The Solomon R. Guggenheim Museum, New York 101
Hampton University Museum, Hampton, Virginia 33, 36, 40–41, 58
Thomas Heath 107
Bill Hodges Gallery, New York 42
Robin Holder 120-121
Charnelle Holloway 98, 99
The Howard University Gallery of Art, Washington, D.C. 18, 30, 44, 53, 69
June Kelly Gallery, New York 119
Sean Kelly Gallery, New York 83
Phyllis Foreman Lawhorn 7
Los Angeles County Museum of Art, California 74
McKissick Museum, University of South Carolina, Columbia 21
Valerie Maynard 79
Keith Morrison 93
Sana Musasama 112
Museum of Fine Arts, Boston, Massachusetts 8–9, 49
Museum of Modern Art, New York 62
Marilyn Nance 87
The National Gallery of Art, Washington D.C. 23
National Museum of American Art, Smithsonian Institution, Washington D.C.—
Art Resource, New York 28, 38, 59, 60, 64, 92, 100
Newark Museum, New Jersey 50–51, 80
North Carolina Museum of History, Division of Archives and History, Raleigh,
North Carolina 19, 20
P.P.O.W. Gallery, New York 15 (bottom), 82
The Pennsylvania Academy of the Fine Arts, Philadelphia 11, 48, 71
Phyllis Kind Gallery, New York 15 (top)
Rhode Island School of Design, Providence 29
Faith Ringgold 72–73
Christopher Wade Robinson 124
Abby Aldrich Rockefeller Art Center, Williamsburg, Virginia 5
Arthur Roger Gallery, New Orleans, Louisiana 70
Luise Ross Gallery, New York 35
Sheldon Ross Gallery, Huntington Woods, Michigan 66
Santa Barbara Museum of Art, California 94–95
Schomburg Collection, New York Public Library, New York 39
Joyce J. Scott 106
Vincent D. Smith 114
Spelman College, Atlanta, Georgia 65
Steinbaum Krauss Gallery, New York 102
Freddie Styles 126
Tennessee Botanical Gardens & Fine Arts Center, Nashville 10
Lloyd Toone 127
The University Art Museum, University of California at Berkeley 75
The Carl Van Vechten Gallery of Fine Arts, Fisk University, Nashville, Tennessee 13, 43
The Wadsworth Atheneum, Hartford, Connecticut 14
John Weber Gallery, New York 109
Weeksville Historical Society, Brooklyn, New York 47
Whitney Museum of American Art, New York 6, 16, 17, 54, 108, 117
Grace Williams 88, 89
Michael Kelly Williams 96
Winston-Salem Delta Fine Arts, The Delta Arts Center, Winston-Salem, North Carolina 12

CONTENTS

INTRODUCTION
4

CHAPTER ONE
THE COLONIAL PERIOD TO 1920
18

CHAPTER TWQ
1920 TO THE 1950s
36

CHAPTER THREE
THE MID-1950s TO THE PRESENT DAY
66

NOTES
126

INDEX
128

INTRODUCTION

African American Art presents a broad selection of African American artists whose work reflects the essence of African American art and the Black aesthetic. It also looks at how these artists struggled for inclusion in society's marketplace and survived the imposition of marginal status on them, their art, and their culture.

Our journey begins in colonial America where African American artists, whether free or bonded, first express a distinctive visual language. It can be seen in rural and urban architectural styles, in handmade furniture, carved walking sticks and canes, and in woven baskets and clay "thrown" pots. Indeed, a carved head at the top of a baluster—replacing the usual staircase pillar—recalls traditional African sculpture, and the likeness of a face carved into the surface of a ceramic jug is reminiscent of ancestral worship. These and many other images and objects serve as visual links to an African past.

But the skills previously applied to adorn objects traditionally used in daily life for religious, political, or tribal instructional purposes are now applied to objects used in the context of New World activities. Thus, objects have new meaning and the skills that produced them are now described in Western terms. Once sacred skills are now called crafts, and what emerges is the first layer of an African American arts and craft tradition based on Africa's ancestral arts— carving, black- and silversmithing, textile designing, basket weaving, and pottery.

During and after slavery, Black men had a gateway to the arts through apprenticeships which refined, exposed, or provided opportunity for the expression and development of their talent in sculpture, painting, and drawing. As skilled artisans, journeymen, or master craftsmen during the development of America's early economy, some Black men were able to save enough money to buy their freedom and that of their families, or even to open small businesses. In contrast, Black female artists were virtually invisible; regardless of their status, they were not permitted to move beyond the boundaries of their household chores and duties. Although a few Black female artists emerged in the mid-nineteenth century, it was far into the

twentieth century before their numbers increased and women made a mark for themselves.

The turn of the century witnessed the beginning of the Great Migration, the expression of new ideas and values, and the emergence of organizations that fostered interracial cooperation. For example, by 1916 more than 160,000 Blacks had migrated to the North; in 1905, a salt-and-pepper coalition of men and women established the National Association for the Advancement of Colored People (NAACP); and in the decades during industrialization a wealthy philanthropic, intellectual, and leisure class emerged that sought not only to support social betterment but also to include African Americans in mainstream life and culture while establishing opportunities for their self-improvement.

More than 92,000 Americans of African descent lived in New York alone, and the majority of them resided in Harlem. African Americans had lived there for more than a decade, and although they paid higher rents and were confronted by hostile Whites, they believed that living in such a clean and quiet neighborhood was well worth the trouble. With their increase in numbers came also their organizations and institutions, journals and magazines, and social and fraternal groups. These numbers mushroomed when the United States entered World War I in 1917 and required workers and others to meet the needs of the war effort. By the end of the 1920s there was a surge in the number of southern Blacks migrating to northern cities—away from the racist South's troubled economy to the North's promises of employment and opportunity.

Figure Holding Vessel

UNKNOWN ARTIST (18TH CENTURY, FAYETTTEVILLE, NEW YORK)

c. 1860; wood (pine); 8 in. high (20.3 cm). Colonial Williamsburg Foundation, Abby Aldrich Rockefeller Folk Art Center, Williamsburg, Virginia.

Carved by a runaway slave, this work projects a posture of dignity, solemnity, serenity, and grace. It is reminiscent of Kongo-influenced art, and, as with other seated objects that support or balance, the aesthetic is one of "noble nonchalance."

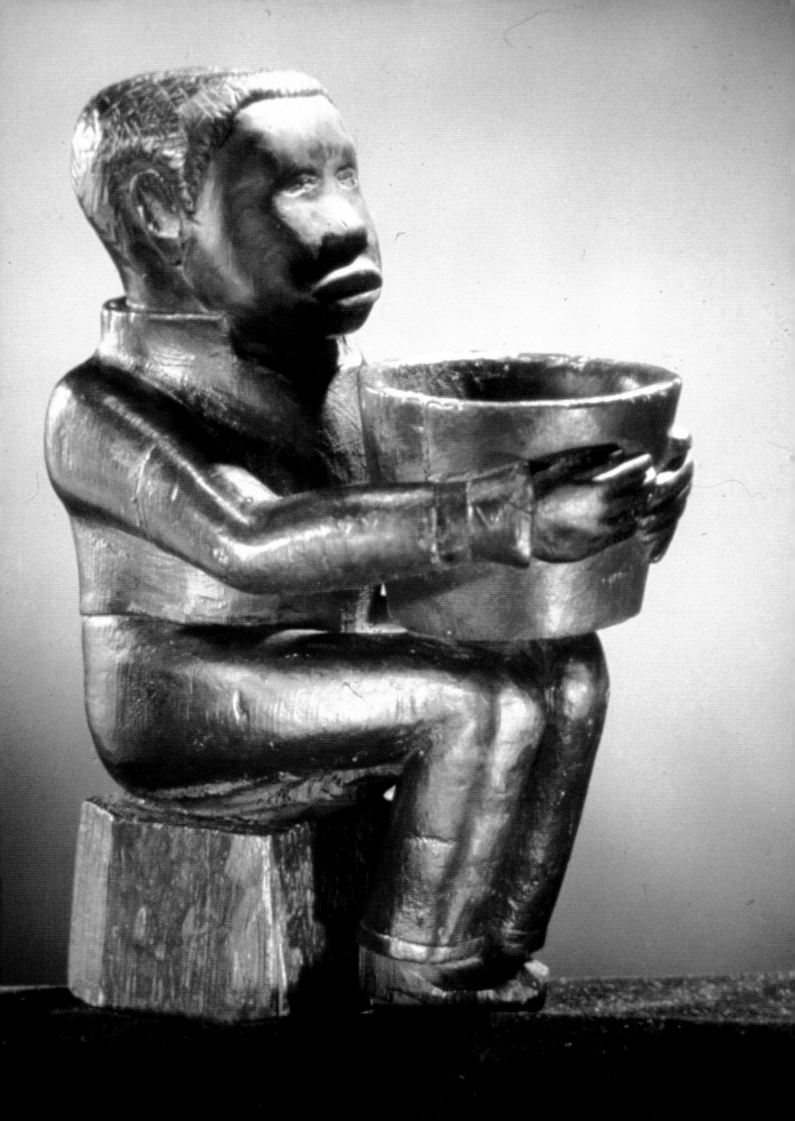

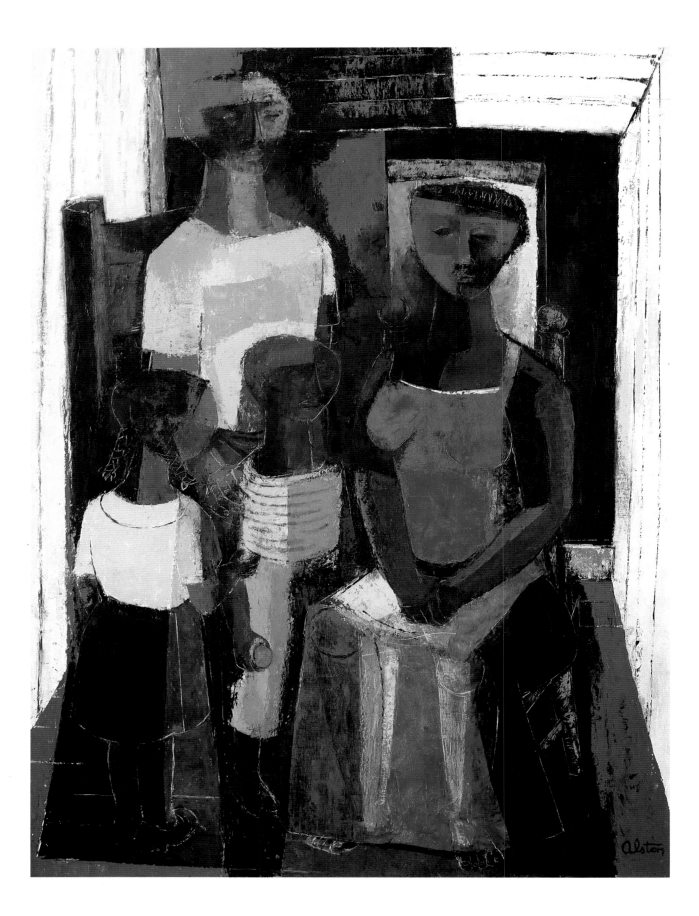

A Black middle class, which had been forming since Reconstruction, emerged after World War I. It, coupled with a network of social and civic organizations, insurance companies, educational and social-service agencies, men's and women's societies, child protective services, and benevolent societies, fostered a national spirit of independence and self-reliance in Black communities throughout the country. This ideology was wedded to a sense of pride and identity that stimulated political activism and a broad vision of potential opportunities for Americans of African descent. Members of Marcus Garvey's Universal Negro Improvement Association, for instance, believed they could return to Africa and reestablish their presence; others involved in self-help groups and organizations believed their battle was in America and preferred to remain and tame the vicious racism. These social and political points of view, subscribed to by writers, musicians, actors, actresses, painters, and sculptors, were also embraced by a large population of socially conscious Whites.

After World War I, two styles of painting predominated: Regionalism and Social Realism. The former style celebrated traditional American values, and the latter focused on the plight of Black people and the poor and working-class people in America living in substandard housing and suffering from unemployment brought on by the Depression. Indeed, the lifestyle and cultural orientation of Blacks became subjects of intense interest, and the state of their education, the repeated lynchings, their hazardous work conditions and low wages, segregated facilities and poor housing conditions—all these were protested against and publicized in poetry, prose, and song.

Family Group

CHARLES ALSTON (1907–1977)

1955; oil on canvas; 48¼ x 35¾ in. (122.6 x 90.8 cm). Purchase, with funds from the
Artists and Students Assistance Fund, Whitney Museum of American Art, New York.
Working as a WPA muralist in New York, Alston created *Magic and Medicine* (1937) for Harlem Hospital. The figurative cubist-Africanesque-style first seen in the mural became an essential part of his artistic signature. His subjects, often Black, read abstractly against the picture plane and appear much like the colorful shadows of African sculpture.

Game Table

JAMES FORMAN (C. 1865–1926)

1905; oak, cherry, mahogany, and ash woods, 29 x 31 in. (73.6 x 78.7 cm).
Courtesy of Phyllis Foreman Lawhorn.
"This game table has always been around our house. There were times when it was taken for granted. One day the table's importance comes rushing into your consciousness. You carefully examine it, running fingers over the five hundred pieces of wood . . . and finally realize the master craftsman your grandfather was . . . and the legacy he's left."
—PHYLLIS FOREMAN LAWHORN, *granddaughter of James Forman*

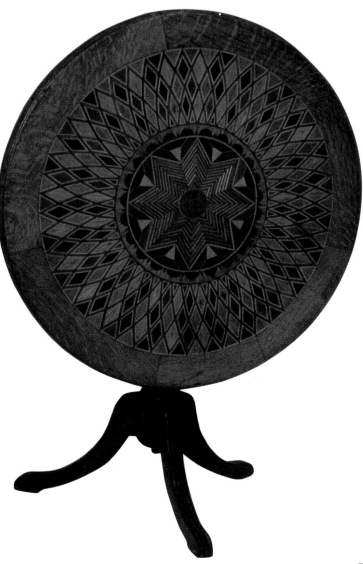

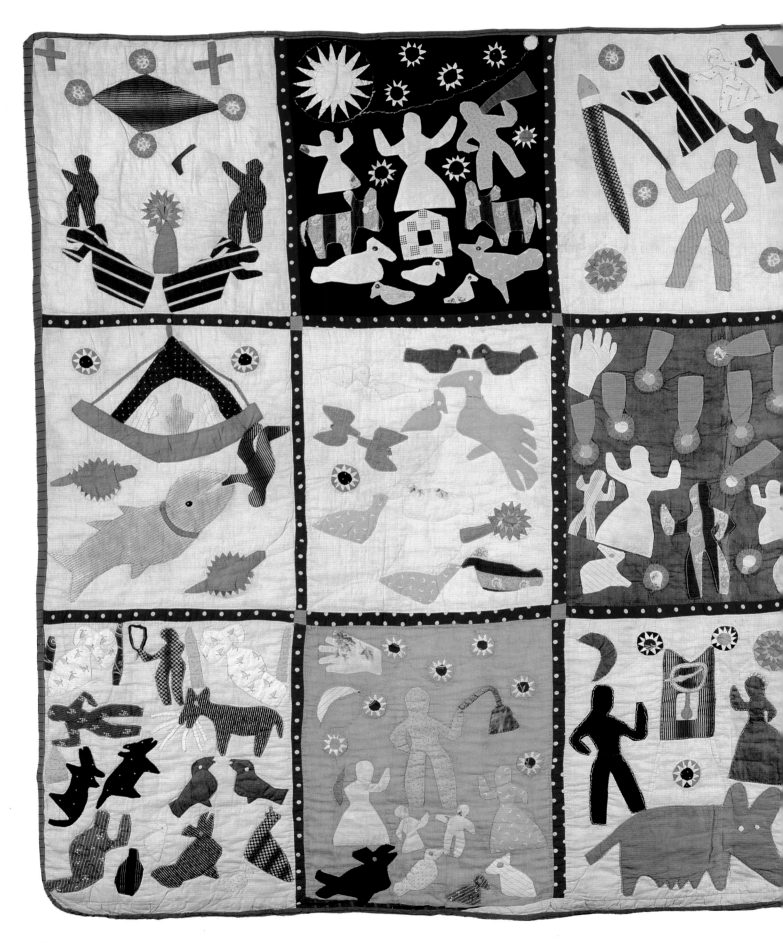

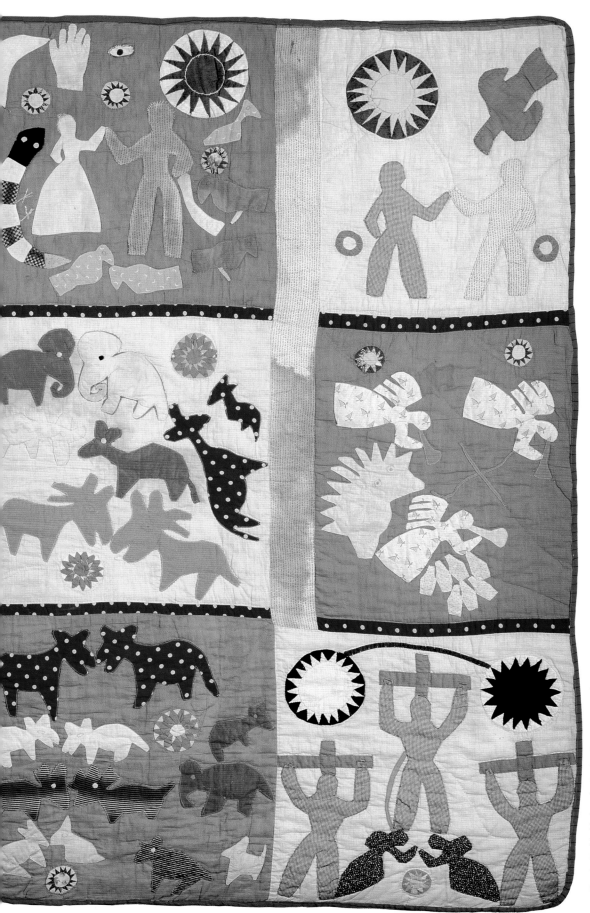

Bible Quilt

<small>HARRIET POWERS</small>
(1837–1910)

c. 1895–1898; hand-stitched,
cotton materials, cotton patched;
69 x 105 in. (175 x 267 cm).
Bequest of Maxim Karolik, Museum
of Fine Arts, Boston, Massachusetts.
Born into slavery in
Georgia, Powers took up
quilt-making as a hobby
after her emancipation.
Only two quilts survive
the artist and they are
African influenced and
illustrate the appliqué
method. This quilt is
composed of fifteen scenes
that join Christian content
and African aesthetics.

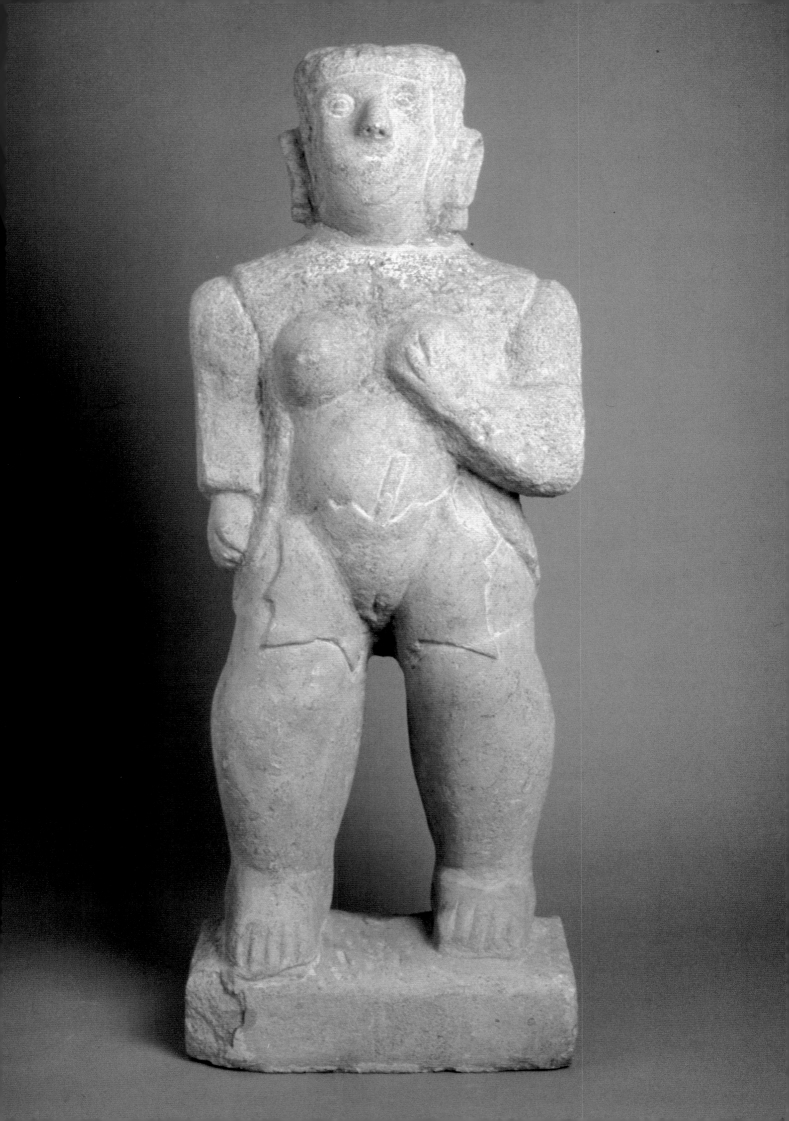

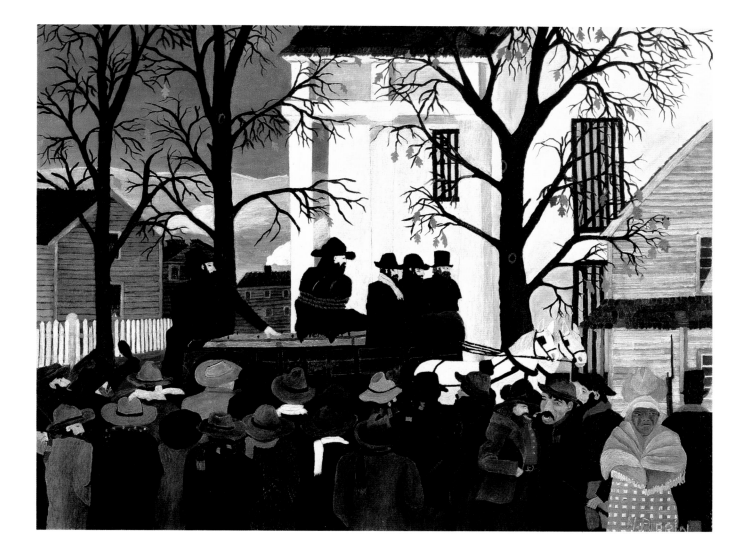

Eve

WILLIAM EDMONDSON (1870–1951)

Early 20th century; limestone sculpture.

Tennessee Botanical Gardens & Fine Arts Center, Nashville.

Self-taught and directed by God to sculpt figures first, and then animals, in 1937 Edmondson was the first Black artist shown at the Museum of Modern Art in New York. Working exclusively in limestone, his intuitive approach to sculpture produced abstracted compact works that have a sense of monumentality and express a high degree of design.

John Brown Going to His Hanging (from the John Brown Series)

HORACE PIPPIN (1888–1946)

1942; oil on canvas; 40 x 30 in. (101.6 x 76.2 cm).

John Lambert Fund, The Pennsylvania Academy of The Fine Arts, Philadelphia.

After suffering a right arm injury in World War I, Pippin, a self-taught artist, inventively "drew" by using a hot poker to gouge holes into wood he later filled with paint. His mother's eye-witness account of John Brown's trial resulted in Pippin's creation of a series dedicated to the saga, using only a black, gray, and white palette.

The voices of writers, both Black and White, galvanized a multicultural movement, called the New Negro Movement or Harlem Renaissance (1919–1929), that celebrated race consciousness, self-reliance, and social assimilation evident among African Americans in Washington, Chicago, Los Angeles, Houston, Detroit, and New York. Publishers published their poetry and fiction in unprecedented editions, Black visual artists found patrons to help support their work, and actors and actresses of color appeared on stages in clubs or theaters exclusively for Whites.

Although the music and art of Black artists animated city life during this period, philosophical differences erupted about the role of American artists of African descent. The burning question was whether or not Black artists should produce art for art's sake or let their art serve to propagandize, inform, and educate.

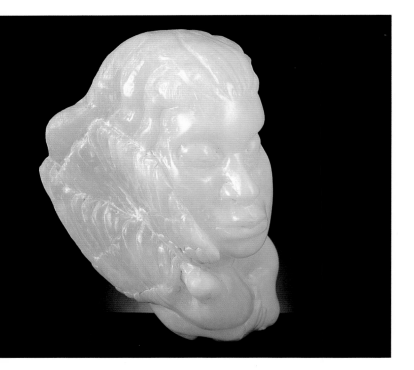

Peace

SELMA BURKE (1901–1995)

1972; Italian alabaster sculpture; 24 in. high (60.9 cm). Winston-Salem
Delta Fine Arts, The Delta Arts Center, Winston-Salem, North Carolina.
The artist's sensitivity to issues is transmitted through her sculptures, which are expressionistic and made from wood or stone. Burke was the winner of the Fine Arts Commission for the District of Columbia competition. Her profile of President Franklin Delano Roosevelt was used on the dime in 1945.

Moreover, American artists were withdrawing their support for the European aesthetic; instead, as in the case of the social realists, they were developing their own. In the midst of this controversy, Alain Locke, a philosopher, cultural critic, and professor at Howard University, called on African American artists to celebrate themselves, embrace their ancestral arts, and explore African art and its possibilities for artistic stimulation.

African American artists were at a crossroads and had nothing to lose. They could respond to Locke's call and use it as an opportunity to develop their own aesthetic or continue to perpetuate the Europeans'. Politically, the African American continued to be a subject of great interest, but African American artists remained excluded from participating in the mainstream exhibition arenas even though their works fell equally into the Social Realist or Regionalist category. So why not stretch out and risk embracing one's own African culture as a source of beauty?

The establishment of the Harmon Foundation by philanthropist William E. Harmon enabled them to make their decision. The foundation's mission was to expand educational and economic opportunities for Americans of African descent and to encourage them to move away from a European aesthetic. These objectives were fulfilled through a series of competitive local and traveling exhibitions that awarded winners cash prizes. *African American Art* will look at the effectiveness of the Harmon Foundation exhibitions in increasing opportunities for Black visual artists and influencing attitudes towards them and their art. Moreover, it will examine the relationship between the foundation and the grassroots network established by Black institutions and other groups and organizations that also supported the growth, development, and exposure of Black artists. Among this network were Atlanta University, Fisk University in Nashville, Tennessee, the 135th Street Young Men's Christian Association in New York City, Chicago's South Side Community Art Center, and Cleveland's Karamu House.

The economic disaster brought on by the stock market crash of 1929 ushered in the Great Depression, a period during which hundreds of thousands of Americans found themselves in lines for soup and public relief. Artists, Black and White alike, were supported by several employment programs administered through such Federal relief projects as the Public Works of Art Project, which commissioned murals and other works of art for public buildings and parks; the Section of Painting and Sculpture in the Treasury Department, which sponsored competitive commis-

sions for artists to create works for public spaces; and the Federal Art Project, which provided artists and related organizations with funds for exhibits, art education, mural and sculpture projects, and research in the Black community. In addition, social and civic groups continued to provide formal and informal spaces for the exhibition of work by Black artists. And through such small stipends provided by the Works Projects Administration or through employment in federally funded community art programs, the African American artist continued to produce and exhibit in the 1930s and 1940s, a period that some consider the second half of the Harlem Renaissance.

Interest in the African American artist waned during and after World War II and through the 1950s. As issues of the visual artist receded into the background, other post-war Americans of African descent saw the opportunity to be part of America's melting pot. They were far more confident than their counterparts of the Reconstruction and the Renaissance. Indeed, they, as well as a contingent of Whites, sought to equalize the political, social, economic, and educational status of African Americans. They slowly chipped away at barriers of discrimination, winning concessions in such areas as employment and education.

By the 1960s the civil rights movement was underway. Assertive and testing the limits of their new-found identity, college students and those in grassroots movements picketed and participated in sit-ins, mass marches, and voter registration drives, all of which served notice to America's racist old guard that no longer could the African American be taken for granted. Under the umbrella of the civil rights movement, the student and grassroots movements created a groundswell of national and international support. And out of these movements emerged the Black power movement, which consisted of militants determined to have access to decent housing, a good education, and employment.

The civil rights movement invigorated Black visual artists. They met and examined their role in light of the burgeoning Black revolution. Community-based

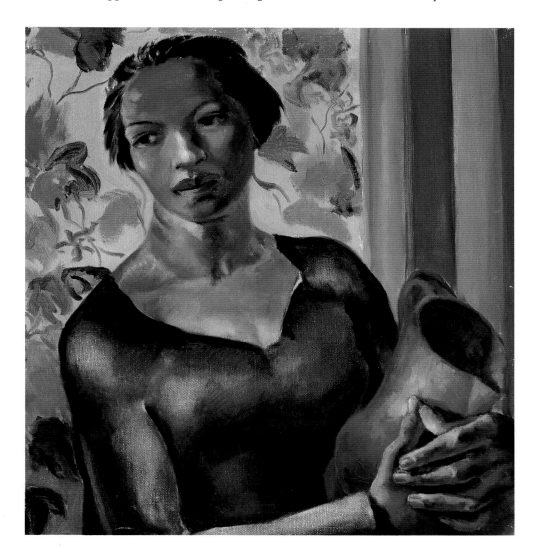

Woman Holding a Jug

JAMES A. PORTER (1905–1970)

c. 1932–1933; oil on canvas;
21½ x 19½ in. (54.6 x 49.5 cm).
The Carl Van Vechten Gallery of Fine Arts,
Fisk University, Nashville, Tennessee.

Winner of the Harmon Foundation's 1933 portrait award, Porter sensitively portrays a Black woman cradled in soft, warm colors who is holding a jug while in deep concentration. In addition to visually interpreting Black life, Porter wrote *Modern Negro Art* (1943), as well as several articles relating to African American art and artists.

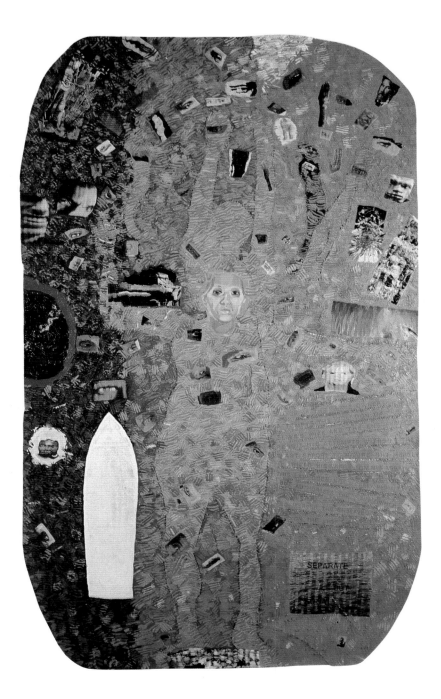

Autobiography: Water/Ancestors, Middle Passage/Family Ghosts

HOWARDENA PINDELL (1943–)

1988; acrylic, tempera, cattle markers, oil stick, paper, polymer photo-transfer, and vinyl type on sewn canvas; 118 x 71 in. (299.7 x 180.3 cm). The Wadsworth Atheneum, Hartford, Connecticut.

The Autobiography Series is about self-interpretation. Here, Pindell includes references to her own African ancestors and to the abuse of slave women in the United States. Pindell's 1988 list, showing how few artists of color were represented by major galleries and museums, created a wave of controversy in the visual arts.

artist coalitions—such as Spiral in New York and the Organization of Black Cultures and AFRI-COBRA in Chicago—all served to challenge and strengthen the identity of Black artists during the '60s and '70s. *African American Art* explores how the presence of these coalitions helped solidify the "Black Art" movement within the visual arts community. As part of this movement, artists examined their role and searched for a visual language that complimented the civil rights movement and could be easily read by the masses.

In tandem with these activities surfaced art-educational and related programs which addressed the problem of Blacks being excluded from gateway institutions and venues in the visual arts. These newly formed institutions and organizations—the Children's Art Carnival, the Studio Museum in Harlem, the Society for the Preservation of Weeksville and Bedford Stuyvesant History, the DuSable Museum, the Afro-American Historical and Cultural Museum, Bob Blackburn's Printmakers Workshop, to name a few—educated the public about Black artists, perpetuated the meaning and value of their art, served as cultural marketplaces and workshop spaces for the creation and exchange of artwork, and functioned as alternative sites for the exhibition of their work.

The existence of these newly formed institutions did not prevent Black artists from picketing American museums that continued to exclude them. Eventually, the work of some artists was included, but of so few, most of whom were male, that a considerable amount of work was left to be done regarding the inclusion of female artists in general and those of color in particular. *African American Art* concludes its examination of the imprint made by African American artists across America's landscape with an analysis of the women's movement, multiculturalism, and the needs of today's Black artists.

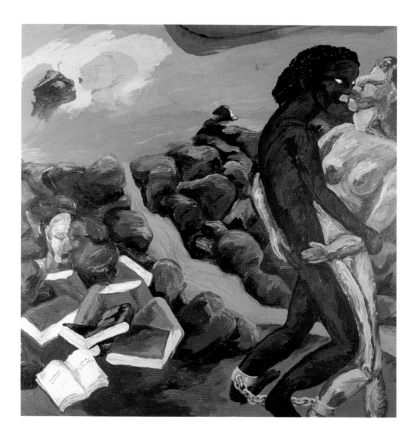

Knowledge of the Past is the Key to the Future (Love makes the World go Round)

ROBERT COLESCOTT (1925–)

1985; acrylic on canvas; 84 x 72 in. (213.3 x 182.8 cm).

Phyllis Kind Gallery, New York.

Truth or consequence and believe-it-or-not notions umbrella Colescott's work. Whether replacing Old Master work subjects with Black images or revealing the fantasies held about Black men and women, the subtext is race and sex and the power relationships between the two.

What You Lookn At

PAT WARD WILLIAMS (1948–)

1993; photo mural with attached color photos and text;

9 x 20 in. (22.8 x 50.8 cm). The P.P.O.W. Gallery, New York.

What You Lookn At examines how Black men are being used as scapegoats and predators of the urban scene. Williams achieves a kind of tromp l'oeil effect to the extent that what is seen changes and is not actually so—the obverse of what is actually happening in the world today.

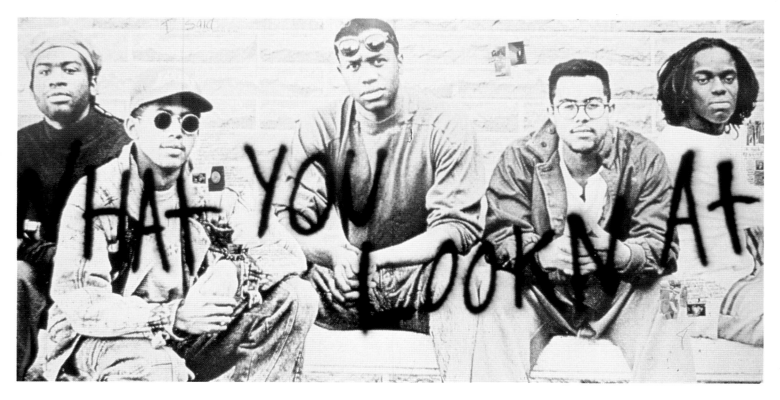

It Shall be Named

RENÉE COX (1958–)

1994; eleven gelatin silver prints,
mahogany, and Plexiglas; 105 x 104 x 18 in.
(266.7 x 264.1 x 45.7 cm).
Whitney Museum of American Art, New York.

A black crucifix has been intri-
cately constructed from a multi-
tude of manipulated photographic
negatives. Cox's Christ, in pose,
posture, and without penis,
provides a chilling allusion to
the figure of a lynched man.

Hollywood Africans—1940

JEAN-MICHEL BASQUIAT (1960–1988)

1983; acrylic and oil paintstick on canvas;
84 x 84 in. (213.4 x 213. 4 cm). Photograph by Bill
Jacobson Studio, New York. Gift of Douglas S. Cramer.
Whitney Museum of American Art, New York.

Basquiat emerged as an artist in
the 1980s, when the cultural mix
included drugs, on which he eventually
overdosed, hip hop, rap, and graffiti.
His works, compact with codes that
expose the nature of power relation-
ships in and outside of the art world,
challenge the social order and express
his concerns regarding racism, and
historical and cultural genocide.

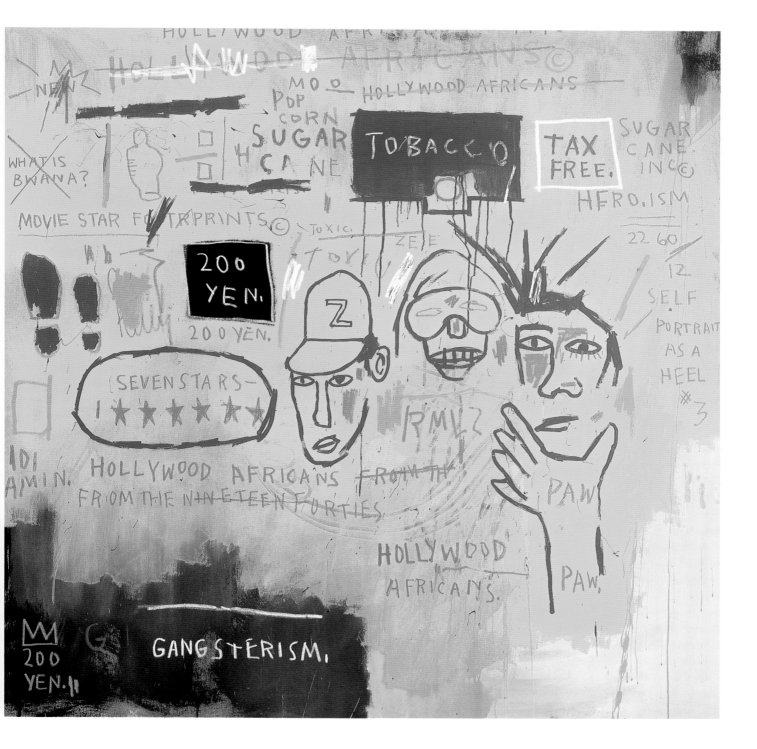

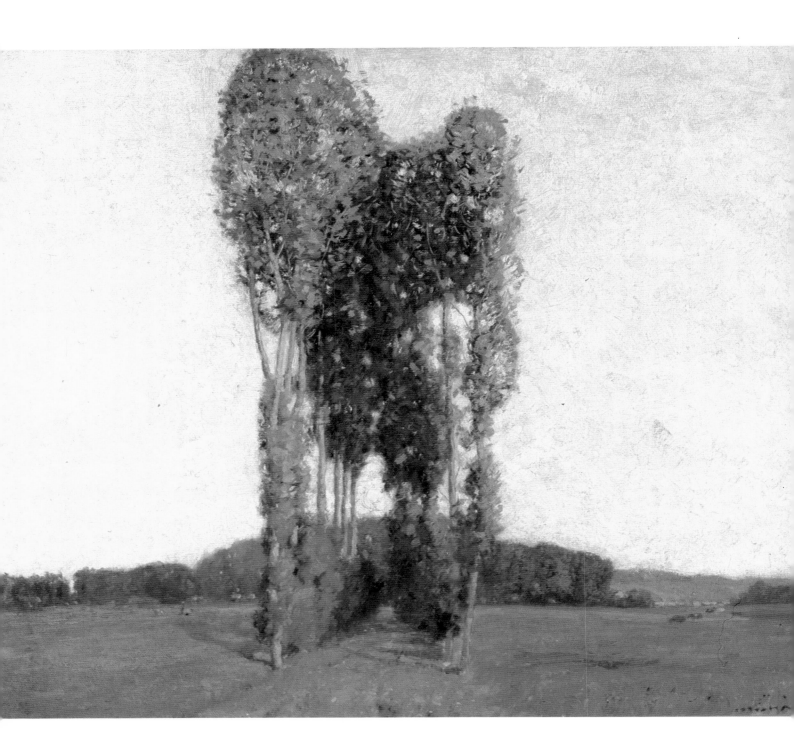

Landscape with Poplars (Afternoon at Montigny)

WILLIAM A. HARPER (1873–1910)

c. 1898; oil on canvas, 23 x 28 in. (58.4 x 71.1 cm). The Howard University Gallery of Art, Washington, D. C.

Acclaimed as a rising talent, this landscape artist died at the age of only thirty-seven. He was influenced by the Barbizon school of naturalist painters, thus atmosphere and attention to detail mark the elements unifying the work.

THE COLONIAL PERIOD TO 1920

*T*he Serpent *slithered through the sea, on that voyage to the Americas called* Middle Passage. *The water was dark. Moonlight barely shone through its waves. The reflection was like black glass, shiny, glittering, deceitful.*

The crossing, always hardest on the women, left their bodies scarred from the pain of torn flesh and ruptured vessels. The screams would soon begin. The moaning and thunderous clapping of feet banging against unbending wood hung thick and heavy in the air, like sea mist and fog.

It happened the next day after letting the women and children up on deck to be washed down, and some other things their men couldn't protect them from. Like a flash of lightening, a whole bunch of them women and children threw themselves overboard, into the sea.

Their resistance, fierce as it was, gave way to a different choice. Their freedom was shaped by their leap. They sought out Yemoja, the Yoruba goddess of sea water. Found, the women chatted with her and looked for pearls while the children played sea games, chased turtles and hung off the fins of dolphins.

Euphoric, their salt-sea-filled lungs pushed visions of a lush green land of flora and fauna, brown earth and sand into their consciousness. They saw home . . . home.[1]

The forced migration of Africans to the New World resulted in the loss of their style of living and system of beliefs. That Africanisms—surviving aspects of African life and culture—appear in the New World at all is tangible proof of Africa's cultural stamina and endurance. African Americans combined the cosmological and visual references of Africa's past to convey their identity and give meaning and definition to their American experience.

As a result, Africa's ethnic imprint can be seen in the ceremonial processions, musical improvisations, and wrought-iron gates and doors of New Orleans; the Low-Country baptisms practiced in South Carolina; the decorated grave sites and gravestones in Kentucky and Georgia; the incantation of call and response, invoking the spirit of the Lord from the isolated revival tents of Arkansas to the brick-and-stained-glass churches of Texas; the wood-carved animals and walking sticks found in Mississippi; and the muddy-water blues belted out from the Mississippi delta to Memphis, Tennessee.

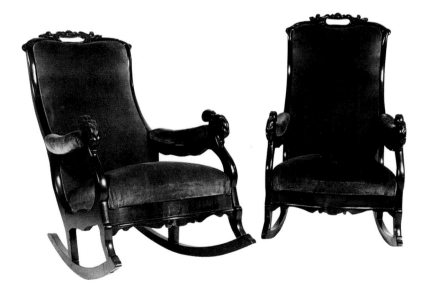

Rocking Chairs

THOMAS DAY (1801–1861)

Courtesy of North Carolina Museum of History,

Division of Archives and History, Raleigh, North Carolina.

Working predominantly in mahogany, Day's intricate carving and African inspired designs were applied to table legs, doors, bed frames, church pews, and chairs.

Having both sacred and secular functions, these rituals and ancestral arts—wood carving, metal forging, weaving, pottery—symbolized the communal values and beliefs embodied in the rites, rituals, and ceremonies unifying Africa's sociopolitical and spiritual systems. As such, they not only bridged temporal and metaphysical realities but also informed and communicated the relationship between mind and spirit, man and nature, life and death. But separated from Africa's cultural ambiance, the religious and sacred functions associated with the ancestral arts had all but evaporated into thin air.

AFRICAN INFLUENCES IN THE NEW WORLD

By the eighteenth and nineteenth centuries, Black people were thoroughly involved in colonial life, contributing significantly to its overall maintenance.

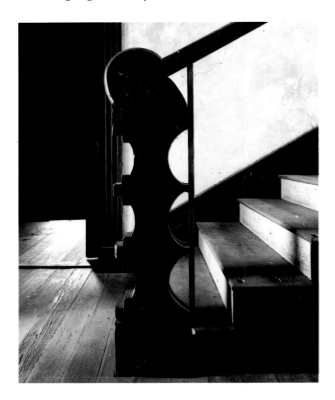

**Newel Post
(Located in Paschal House,
Caswell County, North Carolina)**

THOMAS DAY (1801–1861)

Courtesy of North Carolina Museum of History,

Division of Archives and History, Raleigh, North Carolina.

Day, a freed slave educated in Boston and Washington, moved to North Carolina in 1823 and opened a studio in which he made furniture. To staff his studio he trained the slaves of wealthy Whites, who would recall them when they had learned the craft.

Colonialists depended on and exploited their labor, despite laws controlling their commercial activity. As craftsmen arrived from Europe to the New World, they quickly abandoned their skills to become land- and slave owners. Those who practiced their trades charged exorbitant fees. Thus, free and bonded Blacks were exposed to and used in all manner of industry, not just relegated to the fields.

Indeed, they worked at making stoneware and ceramic utensils; building houses and barns; shoemaking; milling and storing grain; weaving and tailoring cloth; making and repairing guns and tools; and forging iron balconies, window grills, and gates. Moreover, slaves who lived along the coast engaged in water-related tasks and activities which included making nets for fishing and sails and boats for navigating the sea. Learned in their native land, these activities are the backbone of tradition in African American art and crafts. Remnants of the ancestral arts and the application, mostly by anonymous slaves, of the skills associated with these arts to New World trades established the foundation for the decorative arts.

When African-born or first-generation slaves conjured up artistic shapes and forms associated with their African heritage, they contributed to the New World's cultural vernacular. For instance, in the production of rice, Africans in the New World made and used the same large, round, and flat fanner baskets that they had used in Africa to clean the rice after it had been hulled; the only difference was in the materials. Moreover, the percussion, woodwind, and stringed instruments (drum, flute, and fiddle) that the slaves made were similar to their African counterparts. These instruments, and their uses, confirm the carry-over of an African musical tradition in form and style into the New World.

It was not unusual to see slaves expertly using their carpentry and masonry skills in the construction of dwellings for themselves or their owners. The shotgun house, commonly seen throughout the South and in urban settings as a form of cheap housing for poor Blacks and Whites—was derived from Africa. Its counterpart in Africa, the rectangular gable-roofed hut, was built in parts of the continent from which large numbers of Africans were abducted and brought to the Caribbean and other parts of North America. The shotgun house, gabled and windowless, consisted of a series of two, sometimes more, square connecting rooms measuring 8, 9, or 10 feet (2.4, 2.7, or 3 meters) on a side. Wood, brick, or clapboard was used to cover the outer walls of the house, and tin or shingles covered the roofs.

These dwellings were almost always built by free or bonded Africans. From the recesses of their collective memories would emerge the style of the hut once called home. The shotgun houses, huddled together in

a communal style on large plantations, resembled a compound. Even its name—shotgun—is thought to be derived from the Yoruba word *to-gun*, meaning "place of assembly." This basic architectural style existed for more than a century until its structure was altered: Windows opened outer walls and hallways separated the rooms from one another. And when fanciful "gingerbread" shapes adorned the exterior, the shotgun house became the Victorian cottage, whose origin was lost in the mist of time.

AMERICA'S FIRST AFRICAN AMERICAN ARTISTS

The work of Thomas Day reveals the influence of the African ancestral arts. Day, a freed slave educated in Boston and Washington, moved to North Carolina in 1823 and opened a studio in which he made furniture. To staff his studio he trained the slaves of wealthy Whites, who would recall them once trained. Day apprenticed a few Whites, but to maintain his business he owned several slaves. Most of his work was made of mahogany, though some was made of rosewood, cherry, or walnut. After meeting with a family, Day would make a draft of the furniture needs for each room. His African-inspired designs were carved into mantlepieces and head- and footboards of beds, or decoratively applied to table legs, staircases, or door designs. In 1858, however, as the nation moved towards the Civil War, the price of wood became prohibitive and Day's business failed.[2]

"Dave the Potter" also had a distinctive artistic signature. Although little is known about Dave, we do know that he was owned by Abner Landrum, proprietor of the Potterville Manufactory, which produced stoneware in Edgefield, South Carolina. Taught how to read and write by Landrum, Dave worked for Landrum's newspaper, *The Hive*, as a typesetter until its relocation to another part of the state. It is unclear as to the length of his employment with the paper, but in 1831, Landrum gave Dave to his son-in-law, Lewis Miles, who owned Miles Mills. Dave worked at this establishment for more than twenty years as a potter. Throughout the Edgefield area large numbers of slaves and free Blacks worked in the stoneware factories, which were known for their production of utilitarian wares and open-mouthed, bulbous pots of the sort Dave made.

Dave's work as a potter marked the beginning of a ceramic tradition in African American art. Dave's pots, as compared with others, were taller and heavier, and became wider toward the top, which almost always had a ridge around the mouth because of the way in which Dave worked. Literacy served Dave well: He signed and dated each pot and noted, when known, the name of the individual who commissioned him to design it. And, if assisted during the throwing process, he also gave credit on the pot to the

Stoneware Jar

DAVE THE POTTER (1780–1863)

1857; ash glaze inscribed "Lm Aug 24 1857/Dave"
and on opposite side "Pretty little girl on the virge/volca/n/ic
mountain how they burge." McKissick Museum,
University of South Carolina, Columbia.

Dave's work as a potter marked the beginning of a ceramic tradition in African American art and crafts. He signed and dated each pot and noted, when known, the name of the individual who commissioned him to design it.

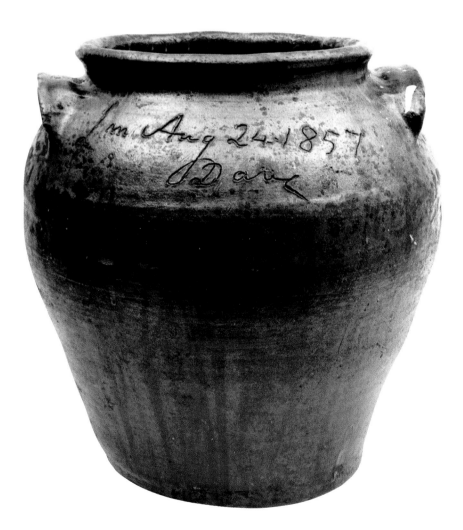

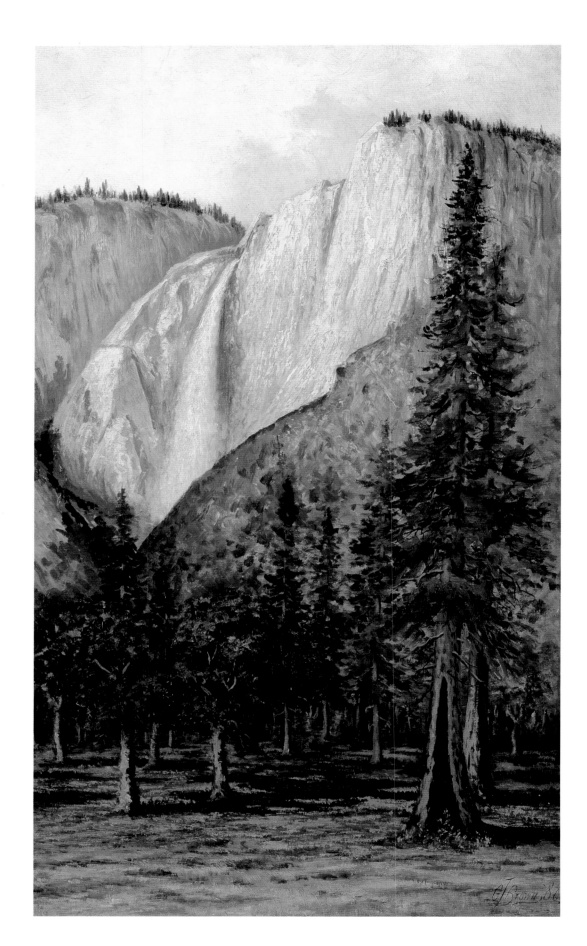

Yosemite Falls
GRAFTON TYLER
BROWN (1841–1918)
1888; oil on canvas;
30 x 18 in. (76.2 x 45.7 cm).
Evans-Tibbs Collection,
Washington, D.C.
The landscape's flat
quality and lack of
fluidity is attributed to
the artist's keen
attention to detail and
training as a draftsman
and lithographer.

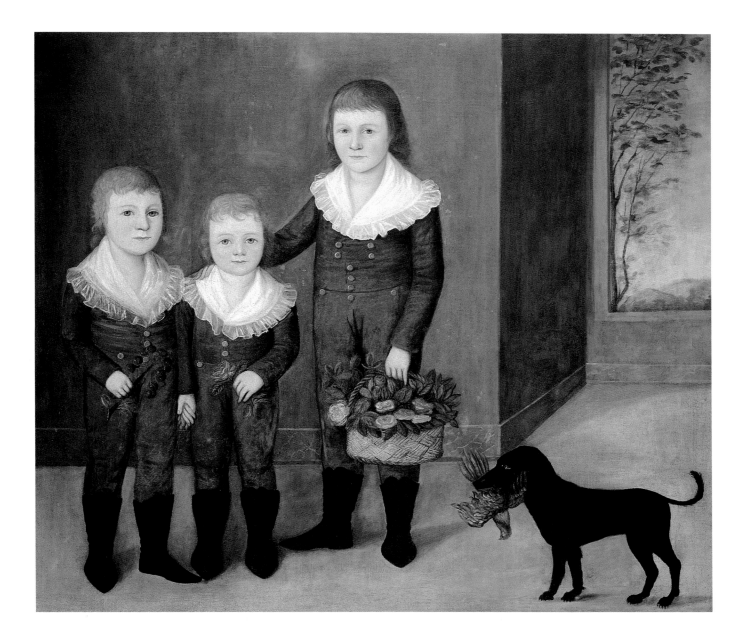

The Westwood Children

JOSHUA JOHNSTON (1796–1824)

1807; oil on canvas, 41⅛ x 46 in. (104.5 x 117 cm). Gift of Edgar William
and Bernice Chrysler Garbish, The National Gallery of Art, Washington, D.C.

One of the earliest Black visual artists to receive professional
recognition, Johnston's career began in 1789. His artwork was greeted
with acclaim between 1796 and 1824. Some of his characteristics
include the sitter in three-quarter view, Sheraton chairs and settees,
elliptical eyes, elaborately treated collars, skirt fabrics, and suits.

FOLLOWING PAGE:

The Blue Hole,
Flood Waters, Little Miami River

ROBERT SCOTT DUNCANSON (1821–1872)

1851; oil on canvas; 29¼ x 42¼ in. (74.3 x 107.3 cm). Gift of Norbert
Heerman and Arthur Helbig, 1928.18, The Cincinnati Art Museum, Ohio.

Painted in the landscape tradition of the Hudson River School,
this work is beautifully executed and considered to be one
of the artists' best. His careful rendering of man and nature
serenely joined as one in the natural environment is striking.

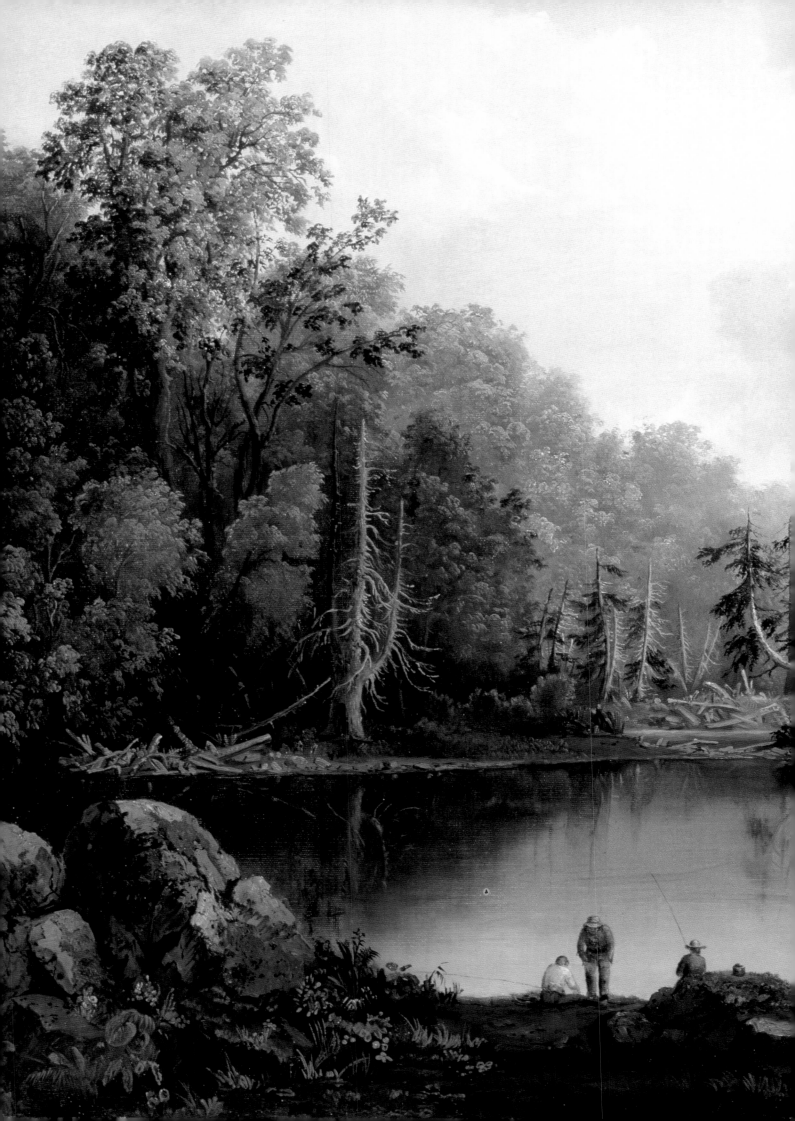

Phyllis Wheatley

SCIPIO MOOREHEAD (18TH CENTURY)

1773; engraving; frontispiece to Wheatley's Poems on Various Subjects,
Religious and Moral. *The Boston Atheneum, Massachusetts.*

Scipio Moorehead was one of the earliest first generation artists,
who although a slave, enjoyed the creative privileges of
freedom. Unfortunately, no other works by the artist survive.

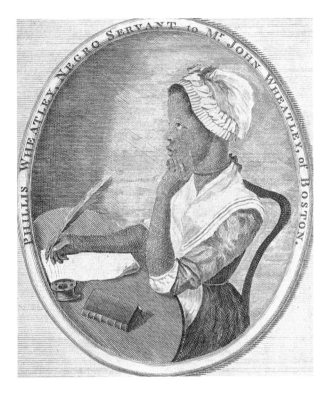

helper. Moreover, Dave inscribed bluesy and simple
poetic rhymes on his pots.[3]

The ceramic tradition in African American art and
crafts unfolded just before the close of Joshua John-
ston's career. Johnston is one of the earliest Black
American visual artists and the first of these to receive
professional recognition. His career began in 1789, his
artwork was greeted with acclaim between 1796 and
1824, and his career ended around 1832. Johnston
experienced both slavery and freedom; his ownership,
however, is still questionable. For instance, descen-
dants of the John Moale family of Baltimore, Mary-
land claimed ownership of Johnston; John Moale,
whose hobby was landscape and portrait painting,
may have initially exposed Johnston to painting. It
has also been suggested that Johnston may have been
a slave or student of the Peale family in Maryland
because of the artistic similarities his work shares with
those of Charles Peale Polk, an artist who painted in
the Baltimore and District of Columbia areas during
the 1780s and 1790s. For thirty years, Johnston, along

with his wife and children, was listed as a "free Negro
House-holder" in the *Baltimore Directory*. And on one
list his house is just a few doors from John Moale's.

Although Johnston lived and worked in Baltimore,
he traveled as far as Virginia and West Virginia com-
pleting portrait commissions. Characteristic of John-
ston's portraits is the three-quarter view. Sitters are
seated on Sheraton chairs and settees that are adorned
with brass-headed tacks against dark backgrounds.
They look straight at the viewer through elliptical
eyes. Their tightly drawn lips lend an overall stiff
appearance to the painting, although hair, jewelry,
and elaborate lace collars and the fabrics of skirts or
suits are carefully rendered.[4]

Scipio Moorehead is another first-generation African
American artist. A slave who was a servant of the Rev-
erend and Mrs. John Moorehead of Boston, Scipio was
taught how to draw by the reverend's wife, Sarah, an
artist and art teacher. He is credited with the rendering
of Phyllis Wheatley, one of the earliest African Ameri-
can poets, who was owned by John Wheatley. Moore-
head's rendering appears as the frontispiece in Phyllis's
1773 edition of *Poems on Various Subjects, Religious and
Moral*. It was not uncommon for Black artists of this
period to first work as carriage, furniture, or sign
painters and then, following the example of Whites,
branch off into painting portraits and landscapes.

The artwork of Scipio Moorehead and Joshua John-
ston is noteworthy because these artists did not have
access to the academies, professional associations, or
teaching institutions that served their White contem-
poraries. Although some Black artists may have been
owned by or in the employ of artists who gave the
Blacks lessons, the majority of these Black artists were
self-taught and endowed with gifts that blossomed with
practice. They followed Euro-American painting tradi-
tion, catered to an essentially White, wealthy, mercan-
tile class, and were not geographically restricted.

SECOND-GENERATION BLACK ARTISTS

As America approached the Civil War, its social and
racial landscape began to change. Slavery still pre-
vailed, but the efforts of abolitionists and others
resulted in the prohibition of slavery in many northern
states and its gradual demise in others. Increasing num-
bers of freed slaves appeared in the North and South.
With the surge in numbers came the establishment of
educational, fraternal, and social institutions, as well as
various manumission societies to meet their needs.

Although a large number of untrained and unedu-
cated freed-men and -women worked as field laborers
in rural areas or as common laborers in urban areas,
after the Civil War, those who had been trained during
slavery as artisans were able to work as such and estab-
lish themselves economically. In general, it was diffi-

cult for African Americans because the Black Codes, which were enacted by southern governments in 1865 and 1866, restricted their movements and quality of life. Despite these laws, many free Americans of African descent engaged in a wide variety of activities and trades not only before but also after the Civil War. In Baltimore, free Blacks were listed as confectioners, furniture makers, druggists, limners, and grocers; in Boston, as engravers, lithographers, paperhangers, druggists, photographers, and teachers of dentistry and law. The same could be said of Blacks living and working in New York, Philadelphia, Atlanta, North Carolina, New Orleans, and Cincinnati.

Whites remained opposed to African American workers, especially those in the artisan class, because they were threatened by their potential loss of power and cultural dominance. Unable to enact legislation to bar them from the trades or eliminate them as competitors, they engaged in an indigenous style of mental terrorism: coupling the myth of the artistic and intellectual inferiority of the African American with the derogatory depiction of his or her image. It is against this backdrop that such nineteenth-century second-generation artists as William Simpson, Patrick Reason, Robert Douglass, Jr., and David B. Bowser sought to build upon the burgeoning tradition of African American art.

Bowser, born in Philadelphia, is believed to have been taught painting by his cousin Robert Douglass, Jr., who allegedly studied with the well-known painter Thomas Sully.[5] Bowser made his living painting banners and emblems for fraternal organizations and fire departments in Philadelphia. In addition, he executed marine and portrait paintings. In a *New York Herald* review of an 1852 exhibition of work by "colored mechanics," Bowser's work is highly praised. It is interesting to note that the label "mechanics," as used during this period, refers to manual laborers, craftsmen, and portrait and marine painters. (In the twentieth century, the label of artist or "mechanic" craftsperson is a class issue in the visual arts.)

Patrick Reason, a Haitian immigrant who migrated to New York, was apprenticed and trained as a printmaker in lithography and engraving. His images were regularly used by abolitionist societies to fight against the institution of slavery. At the early age of thirteen, Reason was commissioned to illustrate the frontispiece of the *History of the African Free Schools*. Later he produced an engraved portrait of Granville Sharpe, the English abolitionist, and rendered a drawing of New York's Governor, DeWitt Clinton. Reason's subjects also included Blacks; his lithographic portrait of Henry Bibb, an escaped slave and abolitionist lecturer, is one such example. In addition, Reason gave lectures at Black literary and abolitionist societies and illustrated many slave narratives. He also spoke out against the plight of Black women and produced the poignant 1835 engraving *Am I Not a Woman and a Sister.*

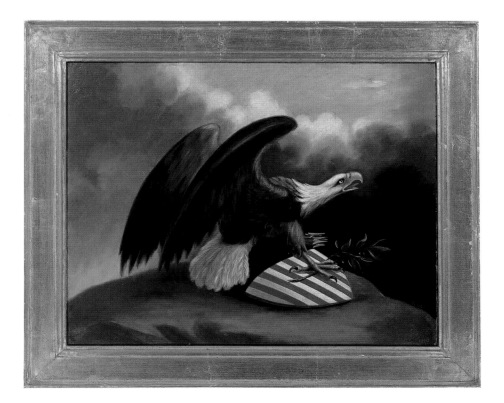

The Bald Eagle and the Shield of the United States

DAVID BUSTILLE BOWSER (1820–1900)

1847; oil on canvas; 15½ x 19⅞ in. (39.3 x 50.5 cm). Atwater Kent Museum, The History Museum of Philadelphia, Pennsylvania.

A Philadelphia-born painter of banners and emblems for fraternal organizations and fire departments, Bowser also painted signs and marine and portrait paintings. Abraham Lincoln purchased a portrait of himself completed by Bowser, and his check became a family heirloom.

THE CIVIL WAR ERA

Through their work, third-generation African American artists such as Robert S. Duncanson, Edmonia Wildfire Lewis, Edward M. Bannister, and Henry O. Tanner, of the mid- to late nineteenth and early twentieth century, also dismissed any ideas of their artistic inferiority and advanced the tradition in African American painting and sculpture. In 1867, at the Philadelphia Centennial Exhibition, Lewis exhibited her sculpture *The Death of Cleopatra*, and Bannister's painting *Under The Oaks* was awarded first prize.

Moon over a Harbor

EDWARD MITCHELL BANNISTER (1828–1901)

c. 1868; oil on fiberboard; 9⅝ x 15¼ in. (24.5 x 38.7 cm). Gift of H. Alan and Melvin Frank, National Museum of American Art, The Smithsonian Institution, Washington, D.C.

One of only a few Black artists to receive artistic training during the nineteenth century, Bannister studied at the Lowell Institute. A free Black man who settled in Boston around 1850, he later moved to Rhode Island where he and several other artists established the Providence Art Club, which later inspired the Rhode Island School of Design.

Duncanson, Tanner, and Lewis traveled and studied abroad and found relief from the racial hostility of America.[6] However, Lewis' experience in Europe was fraught with mixed blessings. As a Black woman she still had to confront the issues of gender and race, not to mention the competitive issues her presence raised among White female sculptors working at the same time in Rome.

Robert S. Duncanson, a major landscape artist and the first African American muralist, was born in upstate New York in 1821. His father was Canadian of Scottish descent and his mother was a free Black woman who was reared in Cincinnati, Ohio. It is unclear when Duncanson moved to Ohio, but when he did, he was accompanied by both parents to Mount Healthy, 15 miles (24 kilometers) outside Cincinnati, which was then part of the Northwest Territory and a refuge for Black people. Even though existing laws required runaways to be returned to their owners, Whites in this part of Ohio seldom enforced them. As a result, the area attracted both free and runaway Blacks who, along with the resident Black population, made up a thriving, albeit small, African American community.

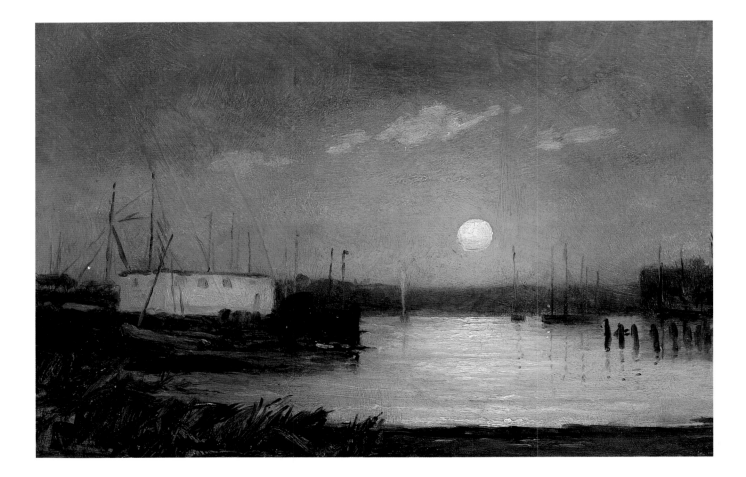

During the 1830s, however the Underground Railroad deposited large numbers of runaways in Cincinnati, and insecure Whites reacted and demanded action. They insisted that the Black Codes of 1804 be enforced and that the movements of Blacks be considerably restricted. One such code required Blacks to show proof of freedom and post a $500 bond, requirements that held them accountable if they did not live there.[7] Subsequently, a significant number African Americans left Ohio, migrated to Canada, and established the town of Wilberforce, Ontario.

ROBERT S. DUNCANSON

Cincinnati, considered both progressive and restrictive, was a booming and prosperous center. Its wealthy mercantile class, like the East's, became patrons of the arts. Both Black and White artists mingled with one another, and the city offered a program of public arts for its residents. Duncanson was exposed to the work of Thomas Cole, founder of the Hudson River School style of painting, which romanticized the environment's natural landscape. He lived and painted in the area during and after the 1820s. During the 1840s and 1850s Duncanson was also exposed to the works of Thomas W. Whittredge, William Sonntag, and Godfrey Frankenstein, who were attracted to the area to work and live.

Recognizing Duncanson's promising potential, the Western Freedman's Aid Society, an abolitionist group, sent Duncanson to Glasgow, Scotland, to study art in or around 1840. During the 1840s and 1850s, his painting style evolved and included still lifes, portraits, historical scenes, and religious scenes. Although Duncanson painted in several genres, guarantying him a consistent income, he pursued his interest in landscape painting during this period. He traveled to Michigan, North Carolina, New England, and Pennsylvania, where natural terrains are excellent subjects for such painting. By 1841, Duncanson was living and working in Cincinnati, and in 1842 the Society for the Promotion of Useful Knowledge sponsored his first exhibition. Although Duncanson created his first landscape in 1844—a pastoral view of Mount Healthy that shows the young artist's first attempts to deal with light, space, and foreground and background relationships—it was the fruit still lifes and floral scenes presented in his first exhibition and thereafter rendered (1842–1849) that established his reputation.

Without the benefit of formal training, Duncanson and other artists of the period often copied or elaborated on engravings to advance their spatial and compositional skills. Another aid that advanced the skill of developing painters was the use of daguerreotypes; Duncanson worked in James P. Ball's successful

daguerreotype studio. Ball was an African American whose substantial Cincinnati business catered to both Blacks and Whites. It is not known whether Duncanson actually assisted Ball with photographing the subjects; however, Duncanson did produce paintings of the daguerreotypes for interested patrons. Another activity that may have influenced Duncanson's expert rendering of landscapes was the execution of diorama

Silence

NANCY ELIZABETH PROPHET (1890–1960)

c. 1922–1930; marble; 12 x 8 x 8¾ in. (30.4 x 20.3 x 22.2 cm). Gift of

Miss Ellen D. Sharpe, Museum of Art, Rhode Island School of Design, Providence.

An early female pioneer, Prophet graduated from the Rhode Island School of Design and studied in Paris, where she lived for ten years. Upon her return to the United States in 1934 she joined the faculty of Spelman College in Atlanta, where she subsequently developed their sculpture program. During the 1930s she was exhibited by the Harmon Foundation and the Whitney Museum of American Art Sculpture Biennials. Prophet's subjects, almost always African American, embody a spirit of quiet pride and self-respect.

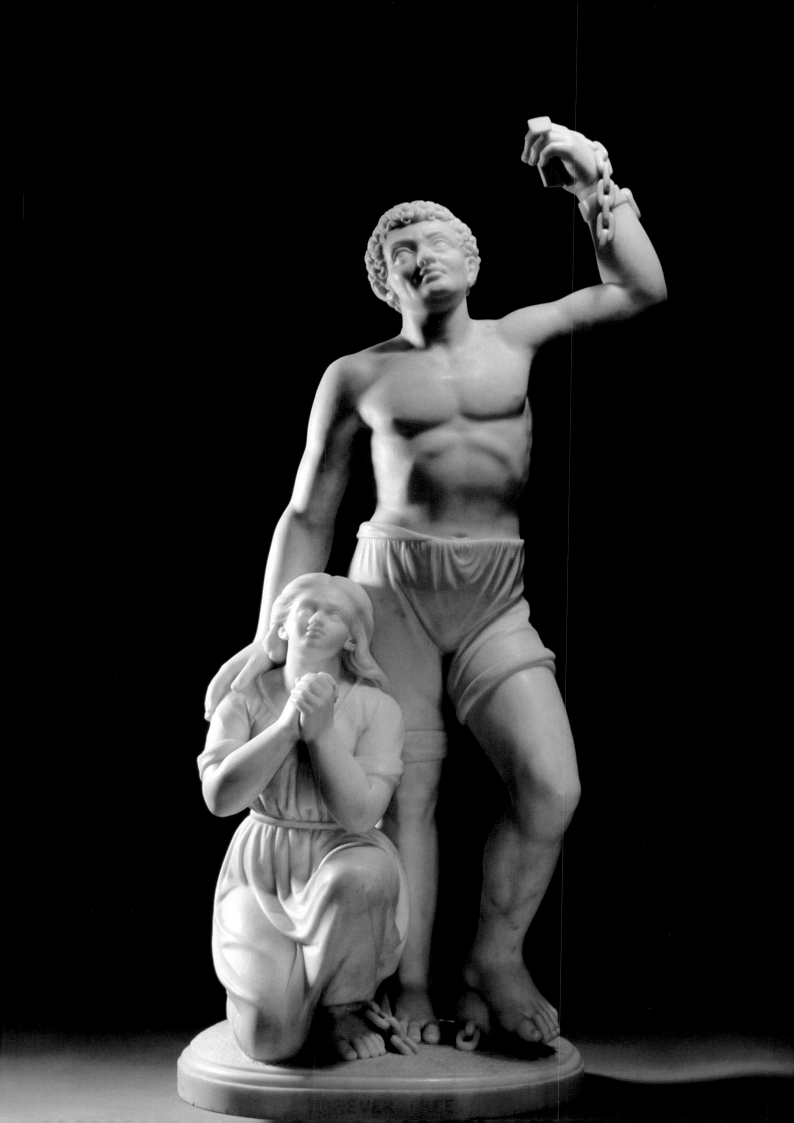

paintings that he and a colleague, Mr. Coates, carried out in 1844.

Duncanson's patrons included wealthy business-men, industrialists, and influential abolitionists of the period. In 1848, Nicholas Longworth, a wealthy lawyer, philanthropist, and abolitionist, commissioned Duncanson to paint eight 6-by-9-foot (1.8-by-2.7-meter) landscape murals in the entrance hall of his mansion (now the Taft Museum). Duncanson completed the murals around 1850. In 1851 he executed his *Blue Hole Flood Waters, Little Miami River*, a painting that demonstrates his experimentation with and mastery of the Hudson River School style. And, 1853, he returned to Europe with Sonntag and John Robinson Tait; they traveled to England, France, and Italy.

During the 1860s, as the country moved closer and closer to political upheaval, Duncanson traveled to Minnesota and Vermont, and he remained in Canada between 1863 and 1865. In 1865, he traveled to Europe, England, and Scotland and returned in 1867; after his return, he separated himself from the roman-tic realism associated with the Hudson River painters. By the time Duncanson returned to Scotland in 1870, he had received commercial and collegial fame. In 1871, he successfully exhibited his paintings in Scot-land and in the United States, and seemed to be at the height of his artistic career. His works, mature in style and thoughtfully executed, demonstrated the artistic capability of African Americans and helped to chip away at myths suggesting otherwise. Duncanson died in Detroit in 1872 at the age of fifty-five of an unknown illness.

EDMONIA WILDFIRE LEWIS

The body of work produced by Edmonia Wildfire Lewis, another third-generation African American artist, also debunked such myths. Moreover, it refuted

Forever Free

EDMONIA WILDFIRE LEWIS (1843–1900)

1867; marble. The Howard University Gallery of Art, Washington, D.C.

The layer of emotion hovering over the work animates this neoclassical rendering of these slaves' response to their new found freedom. The woman, who is looking upward, rests on one knee with her hands clasped in prayer. By her side is a man who has one hand on her shoulder; his other arm is raised and broken chains hang from his wrist.

the opinions of those who believed that women should not pursue careers in the fine arts. Lewis, a sculptor, was the first Black woman to achieve a suc-cessful international career in the fine arts.

Her exact date and place of birth are in dispute. What is known is that Lewis was born between 1843 and 1845 either in Ohio or near Albany, New York. Her father was African American and her mother Chippewa Indian. Lewis' brother paid for her early education in Albany, New York, and also provided financial assistance when she entered Oberlin College in Ohio. (While there, Wildfire changed her name to Edmonia.) After completing high school courses, she entered the college's liberal arts program. In 1862, she was unjustly accused of poisoning her White room-mates and then was beaten, arrested, defended by an African-Indian lawyer, tried by a jury, and subse-quently released on insufficient evidence. The stu-dents, however, continued to torment her, and in 1863, one of them accused her of stealing supplies. Although acquitted, she was not allowed to graduate.[8]

Lewis left Ohio and established herself in Boston, where she opened a studio in the building in which Bannister and other artists of the 1860s had spaces. A letter from Oberlin College introducing Lewis to the abolitionist William Lloyd Garrison was the gateway for her meeting local artists and other abolitionists. Garrison introduced Lewis to the sculptor Edward Brackett, who gave her works to copy as a means of mastering her skills, but that assistance was the extent of her "training."

Working during the period of the Civil War, Lewis included abolitionists Garrison, Charles Sumner, and others as subjects. She also successfully executed a por-trait bust of Colonel Robert Gould Shaw, who had led the all-Black Massachusetts 54th Regiment in the Civil War. Her work was hailed by Harriett Hosmer, a neo-classical sculptor, and in a poem by Anna Quincy, Edmonia Lewis. By making and selling plaster copies of the bust, Lewis raised enough money to subsidize her trip to Europe in 1865, where she opened a studio in Rome.

She made many of her own models and carved her own sculptures rather than using local artisans, as was the common practice. After completing her works, she would send them back to Boston for sale to raise money for materials and shipping. Working in marble, without the benefit of formal instruction, Lewis began to explore subjects that spoke to both her Native

31

American and her African heritage and to the inhumanity of slavery and racial oppression. Examples of such work are *The Freed Woman and Her Child* (1866), *Old Arrow Maker* (1872), and *Hagar* (1875).[9]

Unlike other artists of this period, Lewis, Patrick Reason, and William Simpson freely explored racial images in their work and raised questions for the viewer to consider about the inhumaneness of slavery. This issue of dealing with racial subject matter would become a crucial question for artists in the mid-twentieth century.

HENRY OSSAWA TANNER

Henry Ossawa Tanner is the most renowned African American painter of the nineteenth century. Born in Pittsburgh, Pennsylvania, in 1859, Tanner was one of seven children. His father was a college-educated and seminary-trained African Methodist Episcopal minister who was made bishop in 1888. His mother was a former slave whose mother had sent all of her children North to Pittsburgh via the Underground Railroad. Tanner's mother ran a neighborhood school from the family's home. In 1866, Tanner's father was assigned a church in Philadelphia where the family moved.

Tanner had always been interested in art but did not get support from his family until the work in a family friend's flour business proved too physically exhausting.[10] In 1880, he enrolled in the Pennsylvania Academy of the Fine Arts where he studied under Thomas Eakins and completed two years of training. Of its two hundred–odd students, Tanner was the only one of color. He finished his studies at the Academy in 1882 and tried to support himself as an artist, selling drawings and prints to magazines. In 1888, he left Philadelphia and moved to Atlanta, Georgia. While there, he opened an unsuccessful photography studio, taught drawing at Clark University for two years, and traveled to the Blue Ridge Mountains of North Carolina to sketch Black people. These sketches were the basis for several paintings that he subsequently completed and sold to finance his first trip abroad in 1891.

Tanner made Paris his home and enrolled in the Academie Julian. He made frequent visits to see his family in America while producing paintings that depicted African American subjects: *The Banjo Player*,

The Thankful Poor, and others. His direct portrayal of African American subjects offered a prideful view and dismissed the existing stereotypes. Tanner received recognition of his work in Paris when two of his paintings, *The Bagpipe Lesson* and *The Sabot Maker* (variations on the theme of *The Banjo Lesson*) were hung in the Paris Salon. But it was his *Daniel in the Lion's Den* that received honorable mention in the Paris Salon in 1895.

Tanner's career gained momentum as his paintings continued to receive awards and were purchased by the government of France. After 1895, Tanner almost exclusively explored religious subjects. Rodman Wannamaker, a wealthy Philadelphia businessman living in Paris, sponsored Tanner's trip to Egypt and Palestine in 1897 and 1898. Tanner first gained American recognition in 1899 when the Pennsylvania Academy of the Fine Arts exhibited and purchased his *Christ and Nicodemus on a Rooftop*.

In 1908, the American Art Galleries in New York City presented Tanner in a one-man exhibition of his religious paintings. His style, changed by the turn of the century, had become fluid, impressionistic, and symbolic; light and color were used to shape the emotional content of his religious paintings and landscapes. Although Tanner developed a national and international reputation, the American White press used race as a measure to qualify him as an artist—and his work—describing him as the country's "foremost Negro artist." This practice troubled him tremendously. For Tanner, it reinforced the wisdom of his choice to live outside the racial discrimination that haunted so many African American artists. Considered the "dean of American Painters," Tanner died in Paris in 1937.

The Banjo Lesson
HENRY OSSAWA TANNER (1859–1937)
c. 1893; oil on canvas; 48 x 35 in. (121.9 x 88.9 cm).
Hampton University Museum, Hampton, Virginia.
The soft lighting gently framing the man and boy casts the warm illumination of a halo. Circling the old man and the boy is a quiet intimate intensity—teacher to pupil. The old man's patience and kindness and the boy's effort to seek mastery of the instrument are keenly felt.

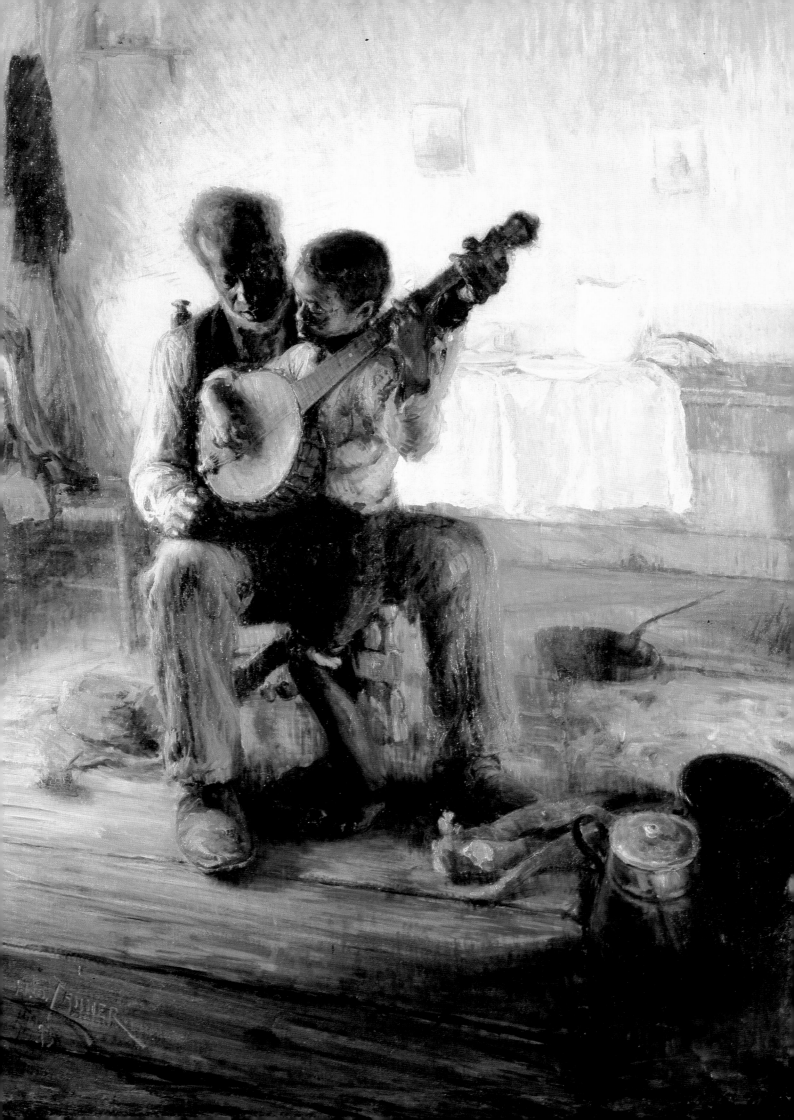

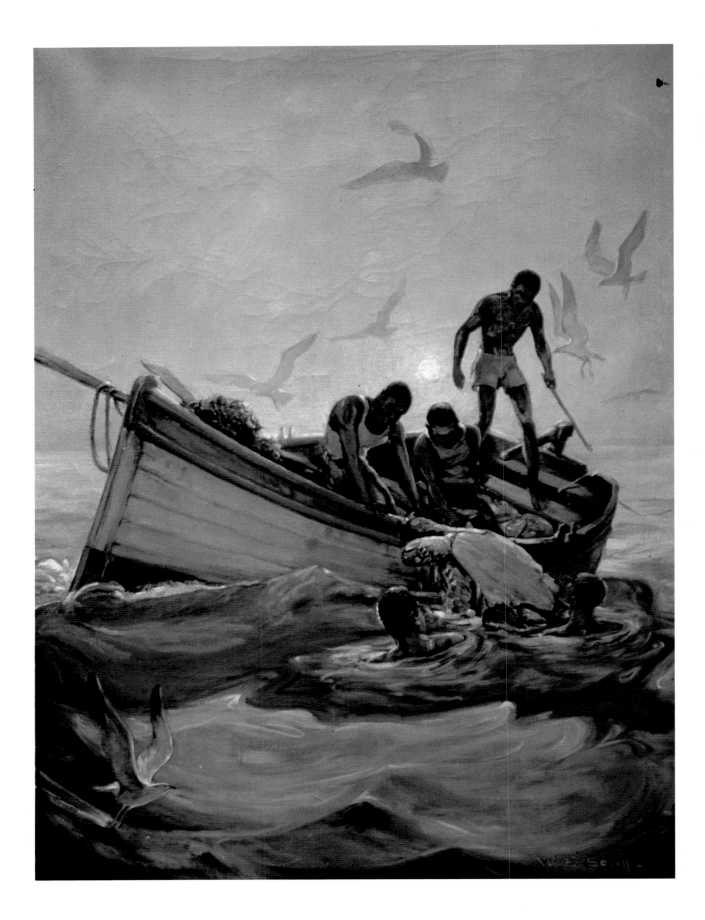

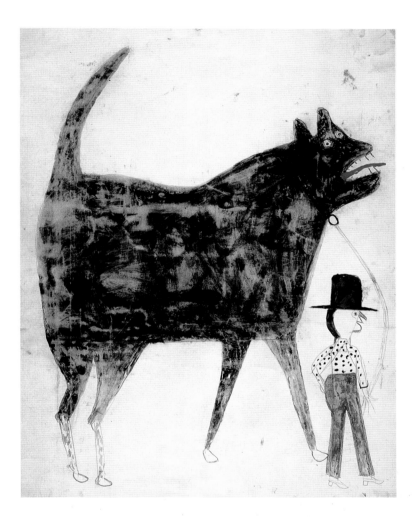

Man and Large Dog

BILL TRAYLOR (1856–1949)

1939–1942; pencil and gouache on paper;

28⅝ x 22½ in. (72.7 x 57.1 cm). Luise Ross Gallery, New York.

Born into slavery on an Alabama Plantation, this self-taught artist began drawing in 1939 at the age of eighty-five. The figures and animals in his black-and-white and colored drawings are spontaneously rendered and read much like West African appliqués, which similarly serve as narratives or chronicles of an event.

Night Turtle Fishing in Haiti

WILLIAM EDOUARD SCOTT (1884–1964)

c. 1931; oil on canvas; 39½ x 29¼ in.

(100.3 x 74.3 cm). Clark Atlanta University

Collection of Afro-American Art, Atlanta, Georgia.

Color explosively animates the sensibility of this seascape, where movement is sifted through a plane of light that bounces off layers of paint, shaping and defining the imagery.

House by the Hill

Wᴉʟʟɪᴀᴍ Hᴇɴʀʏ Jᴏʜɴsᴏɴ (1901–1970)

c. 1927; oil on burlap; 23 x 27 in. (58.4 x 58.6 cm). Hampton University Museum, Hampton, Virginia.

This expressive work of geometric shapes and contours represents a style of painting enjoyed by the artist up through the late 1930s. After that time, his subject matter was almost entirely devoted to Black life and his focus changed to a pseudo-folkloric approach that included flat shapes, simple patterns, and a high degree of design.

1920 TO THE 1950s

Up until the late nineteenth and early twentieth century the images of Blacks popularized in art were largely derogatory. Towards the end of the nineteenth century, though, a small band of African American artists began exploring African art and racial themes in their work; by doing so these artists challenged the existing canon. Among them and of particular note were several women artists—painter Laura Wheeler Waring and sculptors May Howard Jackson and Meta Warrick Fuller. They created the beginnings of a new visual language, the vocabulary of which expressed a sense of racial pride and consciousness.

WOMEN AND ART TRAINING

Unlike Harriett Powers, who could create her quilts within the environment of the home, Jackson, Wheeler Waring, and Fuller, who preferred painting, sculpture, and drawing, sought formal training. Their course of study, though, could only be achieved in predominantly male institutions whose policies and courses of study were developed by men. Male attitudes about the role and place of women significantly influenced instruction. For instance, as late as the 1890s, the policy of those "liberal" art schools that even accepted women for study, stated that only men could draw nudes of either sex. So rigorously was this policy adhered to that Thomas Eakins, a painter and instructor at the Pennsylvania Academy of Art, where Tanner, Fuller, Jackson, and Wheeler Waring studied, was fired after removing the loincloth of a male model during an anatomy lecture in 1885.[11] At a time when artistic achievement was judged by the artists' ability to respond to classical attitudes and sensibilities, female artists were left to master academic drawing and muscular anatomy without access to the nude.

Its therefore not surprising that female artists like Edmonia Wildfire Lewis and others traveled abroad to study and advance their careers in the arts. Annie E. Walker exhibited in Paris as early as 1896 along with Tanner, and Laura Wheeler Waring and Meta Warrick Fuller also studied there at the turn of the century.

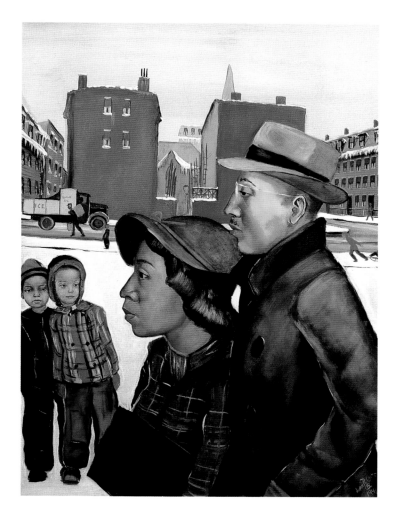

Harriett and Leon

ALLAN ROHAN CRITE (1910–)

1941; oil on canvas; 35 x 30 in. (88.9 x 76.2 cm). The Boston Athenaeum, Massachusetts.
Realistically rendered characterizations of Blacks, as portrayed here, are what Crite is best known for. But, in the 1940s, the artist turned away from such subject matter and increasingly devoted himself to rendering religious imagery.

May Howard Jackson, a sculptor who graduated from the Philadelphia Academy of Art in 1899, chose not to study abroad but created works using racial themes at a time when few others were. *Head of a Negro Child* is particularly poignant, and notable portraits include those of Paul Lawrence Dunbar and W.E.B. DuBois. Her impressive exhibition history included shows at the National Emancipation Proclamation Exposition in New York in 1913, the Corcoran Gallery in 1915, and the National Academy of Design in 1916 and 1928.

Laura Wheeler Waring attended the Pennsylvania Academy of Fine Arts and in 1914 was awarded a scholarship that allowed her to study for a year (1924–1925) in Paris. She produced socially relevant art that was realistically rendered in its exploration of Black life as an artistic theme. Similar thematic concerns would also be explored in the works of such artists as Aaron Douglas, William H. Johnson, Palmer Hayden, and James Van Der Zee, who would follow in the footsteps of Jackson, Wheeler Waring, and Fuller and gain prominence during the Harlem Renaissance (1919–1929). These artists among others advanced the burgeoning artistic tradition in African American art. Their works abandon the European tradition and explore racial themes and the potential influence of African art, while glorifying and celebrating African American folklore and culture.

META WARRICK FULLER

Meta Warrick Fuller's work, which incorporated African and Egyptian themes, expressed a variety of emotions in its examination of African American life and times, and picks up where Wildfire Edmonia Lewis' drops off. In 1907 Fuller was commissioned by the Jamestown Tercentennial Exposition to create a sculpture illustrating the history of Blacks in America. Her sculpture *Ethiopia Awakening* idealizes the conditions of African Americans through a female figure, and her sculpture *Mary Turner* (1919) memorializes the lynching of a Black woman and symbolizes her struggle for self-definition and freedom.

Anne Washington Derry

LAURA WHEELER WARING (1887–1948)
1927; oil on canvas; 20 x 16 in. (50.8 x 40.5 cm).
Gift of the Harmon Foundation, National Museum of
American Art, The Smithsonian Institution, Washington, D.C.
The lifelike quality softly animating the painting is a tribute to the artist's mastery over romantic and expressive elements.

Ethiopia Awakening

META VAUX WARRICK FULLER (1877–1968)
1914; plaster, 5 ft. 6 in. (1.67 m).
Photograph by Manu Sassoonian.
Schomburg Collection,
New York Public Library, Astor,
Lenox and Tilden Foundations.
The quiet strength and dignity depicted in the sculpture powerfully symbolize the emergence of Black life and culture in America.

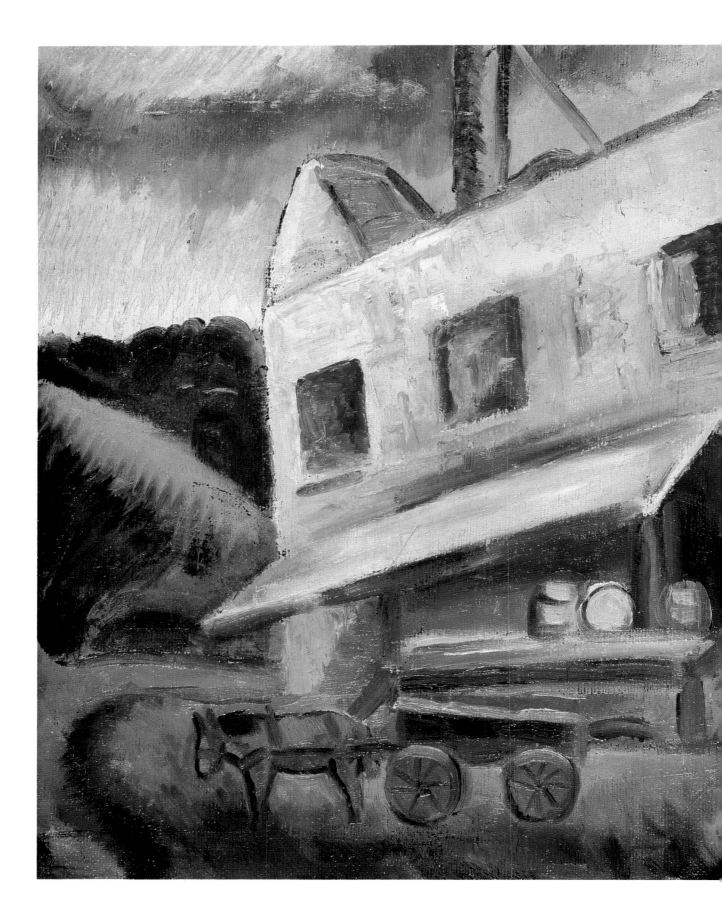

In 1909 Meta Warrick married Harvard professor Dr. Solomon Fuller, a psychiatrist and neuropathologist. They settled in Framingham, Massachusetts, where she became active in the arts community as a member of the Boston Art Club and the Wellesley Society of Artists. Fuller not only created sculptures but also designed stage lighting, built theater sets, created props and costumes for Black and White theater companies, studied play writing, and wrote plays under a pseudonym She spent as much time with her theater activities as she did creating her sculptures.

Even after her studio burned down, destroying the bulk of her work, Fuller continued to work. It was not easy, though, as acting the role of a university wife was difficult given the prevailing attitudes. She was expected to focus all of her energy on her husband and in support of his work, not her own. To make matters worse, her husband became ill and eventually became totally blind; Fuller nursed him until his death.[12]

THE HARLEM RENAISSANCE

Fuller had the advantages that come with social, economic, and class status, but she and other Black women remained vulnerable to the attitudes of the post-Victorian era that thwarted their individual talents. The acceptance of the right of women to vote in 1920 did not empower Black women as it did others. From the days of reconstruction forward they were more able than ever before to advance their education, but this was a concession made to them because Black women were needed to teach the masses of uneducated Blacks. Many of the Black women artists who had an education, income, and access to exhibition opportunities were middle-class. They, more likely than not, had initiated career objectives prior to marriage (or remained unwed). Some opted to study abroad to escape sexism and racism; they continued to do so—as did men—well into the twentieth century. But the majority of Black women artists remained in the United States. It would be the 1970s before any significant change would occur for women artists in general and those of color in particular.

By 1924, 150,000 people of color from Africa, the Caribbean, Latin America, and the American South

The Old Mill

MALVIN GRAY JOHNSON (1896–1934)

c. 1934; oil on canvas; 20½ x 24¼ in. (52 x 64.1 cm).

Hampton University Museum, Hampton, Virginia.

A student of New York's National Academy of Design, Johnson received public recognition for his painting *Swing Low, Sweet Chariot* (1929). His work, though strong, feels soft and expresses a subtle abstract quality that embraces cubist elements.

Harlem Turns White

NORMAN LEWIS (1909–1979)

1955; oil on canvas; 50 x 64 in. (127 x 162. 5 cm). Bill Hodges Gallery, New York.

New York born and bred and a student of Augusta Savage, Lewis was politically astute. A member of the Artists Union in the 1930s and Spiral in the 1960s, his early figurative works were semi-abstracted cubist representations that later evolved into a non-figurative style with abstract elements that gave way to textures and patterns.

were living in Harlem. Their numbers gave way to a newly solidified Black middle class that produced a fresh breed of political and intellectual leadership. Notably, it included Alain Locke, philosopher and cultural critic; W.E.B. DuBois, author, sociologist, and founding member of the National Association for the Advancement of Colored People; and Marcus Garvey, cultural nationalist and founder of the Universal Negro Improvement Association. These men led the charge, igniting a new sense of identity, self-awareness, and self-respect amongst the Black working and middle classes.

Harlem exploded as the mecca of social and cultural independence with its art and cultural institutions, social and entertainment clubs, newspapers and journals, benevolent societies, businesses, and fraternal organizations. The Harlem that came to be known as the Black Capital of America spawned a literary and artistic movement as well as celebrating and promoting race consciousness. The wingspan of the movement's philosophy spread to other cities around the country, like Boston, Chicago, and Washington, DC. But Harlem was on the cutting edge, and what was called the New Negro Movement, between 1919 and 1929, was also called the Harlem Renaissance.

Whites came uptown to tap their feet to the rhythms of the new music called jazz. They joined Black artists and writers at salons where they discussed social, literary, and philosophical views. The "Negro" was in vogue and was the popular subject of writers and social scientists alike. A new-found American nationalism appeared to be stimulating a slow but gradual shift in American ideas and attitudes. Blacks and Whites witnessed and expressed the great divide between the promise of freedom to the Negro and its chilling unfulfillment. Subsequently, such social and political organizations as the Commission on Interracial Cooperation and National Association for the Advancement of Colored People struggled to broaden their ideologies and forge new and stronger relationships which benefited Blacks and raised the consciousness of Whites.

Philanthropic organizations, as the benevolent arm of industrialists and others of wealth, felt obligated to advance the plight of the Negro. The John D. Rockefeller, Harmon, Phelps-Stokes, Carnegie, and other foundations established educational, social, and cultural programs for Blacks in the 1920s and 1930s much the same way the federal government would do in the 1960s. Andrew Carnegie built libraries in Black communities as part of the general library building program he sponsored. Indeed, in 1926 the Carnegie Corporation purchased the library holdings of Arthur Schomburg for Harlem's 135th Street Public Library, and then provided enough funds for Schomburg to be hired as the curator of the collection.

These social and political changes were influenced by the booming post-war economy, the return of veterans, both Black and White, and America's victory abroad. To be sure, they undergirded the American Scene, an art movement prevalent during the 1920s and 1930s which, ironically, prompted the African American artist to explore racial themes in his art. This movement—a style of figurative painting—expressed the two different views of American life held by the Regionalists and the Social Realists. The former painted scenes of an idyllic America, thereby glorifying its values and virtues, while the latter

Head of a Boy

WILLIAM E. ARTIS (1919–1977)

1940; terra cotta sculpture; 10 in. high (25.4 cm).

Department of Art, Fisk University, Nashville, Tennessee.

Black children and youth dominate the works of Artis, who arrived in New York from North Carolina in 1927. A student of Augusta Savage, Artis later taught classes at the 135th Street Branch of the YMCA. Winning the Harmon Foundation's sculpture award in 1933 led to his Art Student League scholarship.

expressed concern about and criticism of the country's obvious poverty amidst plenty. They painted scenes about the excessive commercialism, empty values, and economic problems of American society, as well as ones concerning the inequities and injustices shaping Black life. By doing so they made room for African American artists, who identified with them, to speak for themselves.

Alain Locke, philosopher, historian, and cultural critic, laid out the tenets of this Black artistic movement in a 1925 issue of *Survey Graphic* magazine. He urged Black artists to take pride in their ancestral arts and to look to Africa for artistic inspiration. He suggested that the Renaissance's atmosphere of cultural plurality was an opportunity for them to collaborate and participate in the life of the society at large—to express their race pride without compromise, and by doing so, promote, enhance, and preserve their own cultural heritage.

AARON DOUGLAS

Aaron Douglas, like Waring, Fuller, and Jackson, also explored racial themes in his art and turned to Africa as a source of artistic inspiration and beauty. He received his Bachelor of Fine Arts from the University of Nebraska and his master's degree from Columbia University. In New York Douglas met Winold Reiss, an artist who later became his teacher and source of encouragement for Douglas to accept his African heritage and its many artistic possibilities.

By studying African art Douglas was able to combine his knowledge of classical art with African art's cubist forms. As a result he developed his own style of modernism. His work became highly stylized: The elongated and angular figures populating the picture plane abstractly mimic movement and pulsate across the canvas's surface. Douglas knew many of the literary personalities of the New Negro era and illustrated the works of such figures as DuBois, Countee Cullen, Langston Hughes, and James Weldon Johnson. Moreover, his work frequently

The Creation

AARON DOUGLAS (1899–1978)

1935; oil on masonite; 48 x 36 in. (121.9 x 91.4 cm).

The Howard University Gallery of Art, Washington, D. C.

Exploring racial themes in his art, and Africa as a source of inspiration and beauty, Douglas effectively combines aspects of classical and African art to a kind of African modernism that celebrates African American life and culture.

appeared in *The Crisis* and *Opportunity* magazines. His works almost always articulated some aspect of the African American experience.

As one of the earliest African American muralists, he completed his first for the New York Ebony Club in 1927. This was followed by another for Fisk University which he completed in 1929 with the assistance of the senior artist, Edwin Harleston. In 1931 Douglas traveled to Paris; upon his return was commissioned to produce the mural *Aspects of Negro Life* (1934) for the Countee Cullen Branch of the New York Public Library. The mural illustrated the history of African Americans, and serves importantly as a signature work of the Harlem Renaissance.

The works produced and exhibited by William H. Johnson and Palmer Hayden also gave way to a new and exciting visual language. Johnson developed a simple, straightforward, two-dimensional style that was expressive and rendered his figures flat on the picture plane. He produced all manner of works expressing aspects of African American life and culture, often in easily understood folkloric terms which had great public appeal.

THE PHOTOGRAPHY OF JAMES VAN DER ZEE

Painters and sculptors active through this period and beyond were not the only artists creating a new iconography that advanced the tradition of African American art. Indeed, James Van Der Zee, the photographer, also played an important role in transforming the image of the African American in American art.

Van Der Zee opened his first studio in 1916 on 135th Street in Harlem. He documented the life and culture of Harlem from before the Renaissance up through the Depression, two world wars, and beyond. As the official photographer for Marcus Garvey and the UNIA, his photographs captured every aspect of this early "Black Power Movement," its charismatic leader, the pageantry of its parades, and the glorification of what it stood for.

Van Der Zee's photographs are particularly important because they surfaced at a time when African American artists were at a crossroads—struggling with breaking away from impressionism and classicism and being challenged to explore racial themes and African art as a source of inspiration.

Like early American paintings, the function of Van Der Zee's photographs also served to record the social status and prominence of the sitter. Not unlike some

Old Oaken Bucket

WILLIAM McKNIGHT FARROW (1885–1967)

1938; watercolor and gouache on paper; 12 x 10 in. (30.4 x 25.4 cm).

Clark Atlanta University Collection of Afro-American Art, Atlanta, Georgia.

An active Chicago-based painter and printmaker, Farrow attended the Art Institute of Chicago. In 1924 his work was exhibited in New York at the 135th Street Branch of the Public Library; he was also regularly a part of the exhibitions of the Harmon Foundation, including their traveling exhibitions.

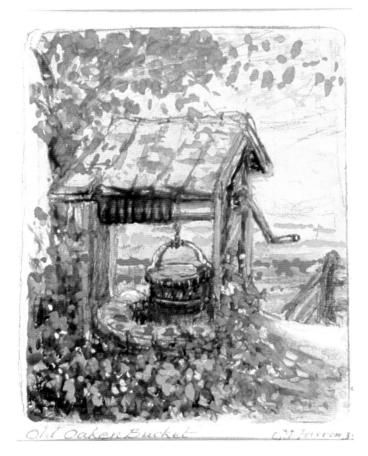

Old Oaken Bucket

early American self-taught painters, Van Der Zee also paid particular attention to the smallest detail. He was well know for his artistic approach to photography and his ability to enhance the image of his sitters by scratching directly into the negative to remove or add beauty marks, to replace hair where there was none, or to enrich facial tones. It was not uncommon for him to colorize the clothing or makeup of his sitters. Nor was it uncommon for him to hand paint into his photographs elaborate backdrops, landscapes, fireplaces, or other elements that he thought placed the final image he had captured in its proper perspective.[13]

PHILANTHROPIC AND COMMUNITY SUPPORT

Although racism continued to result in the exclusion of Black artists from White gallery and museum exhibitions, a network of foundations, community-based African American groups, organizations, and activities—Young Women's and Men's Christian Associations, the Tanner Art Students Society of Washington, DC, the Arts and Letters Society of Chicago, the Chicago Art League, a division of the Wabash YMCA—played a crucial role in educating the public, supporting the work of Black artists, and changing the standards by which they were judged.

For instance, in 1921, 1922, and 1923, Arthur Schomburg, the historian and bibliophile, organized a series of exhibitions at the 135th Street Young Men's Christian Association which included paintings, sculptures, and works on paper by sixty-five African American artists from New York, Washington, Chicago, Boston, and Philadelphia—Meta Warrick Fuller, Edwin Harleston, William Farrow, Palmer Hayden, and James Wells were among them. An African American exhibition network emerged, in addition to community- based organizations and individuals supporting the exposure of Black artists. *The Crisis* magazine (the literary arm of the NAACP) and the Urban League's *Opportunity* sponsored competitions that resulted in the work of African American artists being featured inside its pages and on its cover.

The efforts of the Harmon Foundation encouraged and advanced the growth and development of the African American artist from the late 1920s through the 1930s. It considerably changed the way in which American artists of African descent were viewed and was a vehicle through which many of them received critical and commercial recognition. Between 1928 and 1933 the foundation sponsored five juried exhibitions and showed some five hundred works of art by 125 African American artists. It awarded cash prizes and encouraged Black artists to respond to their cultural orientation and use it as artistic kindling for the production of their paintings, prints, drawings, and sculptures.

Cover illustration for
The Crisis, A Record of the Darker Races

VIVIAN SCHUYLER KEY (1905–1990)

February 1929; watercolor wash. Weeksville Historical Society, Brooklyn, New York.

Unable to find work as a fine artist after graduating from The Pratt Institute in 1926, Key earned a living by painting designs on fabric and giftware. As a free-lancer she designed maps and charts for W. E. B. Dubois and illustrated a number of covers for *Crisis* magazine.

THE
CRISIS
A Record of the Darker Races

FEBRUARY
1929

15c THE COPY $1 50 THE YEAR

Julius

RICHMOND BARTHÉ (1901–1989)

1942–1943; bronze sculpture; 8¼ in. high (20.9 cm). Henry D. Gilpin Fund, The Pennsylvania Academy of the Fine Arts, Philadelphia.

The style of this early twentieth-century sculptor echoes aspects of African art. Barthé's expert rendering of human anatomy produced works with lithe and flowing movements. He was consistently included in the juried exhibitions of the Harmon Foundation, the Whitney Museum of American Art, the Metropolitan Museum of Art, and the Pennsylvania Academy of Fine Arts.

Although Black women artists participated in the Harmon Foundation exhibitions their numbers were small. Out of a total of forty-two artists in the initial 1928 exhibition, eleven were women; in 1930 there were ten women out of a total of forty-two exhibiting artists; eight women out of a total of fifty artists exhibiting in 1931; and seven women out of a total of fifty-seven exhibiting artists in 1933.

The Harmon Foundation sometimes acted as "agent" for artists—it was not uncommon for the foundation to help artists sell their works. After all, Harmon was essentially interested in the socio-economic status of the African American and the exhibitions, the awards, and the possibilities of artwork purchases established financial footing for African American artists during and after the Depression years.

The exhibitions were mounted locally for special events and also traveled outside of New York, thus exposing artists to new and national audiences. The foundation was particularly interested in providing more opportunities for African American artists and advancing the careers of lesser known artists, some of whom included William H. Johnson, Hale Woodruff, Malvin Gray Johnson, Richmond Barthé, Sargent Johnson, Augusta Savage, Lois Mailou Jones, Palmer Hayden, James Porter, Elizabeth Prophet, and Beauford Delaney. These artists were the new young modernists who were busy experimenting with abstraction, its relationship to African art, and the possibilities it offered for advancing the African American aesthetic. Moreover, they would ultimately serve as the standard-bearers of African American art. Importantly, they celebrated African American history, life, and culture through their works.

Ubi Girl from Tai Region

LOIS MAILOU JONES (1905–)

1972; acrylic on canvas; 60 x 43¾ in. (152. 4 x 111.1 cm). Charles Henry Hayden Fund, Museum of Fine Arts, Boston.

"I believe it is the duty of every Black artist to participate in the current movement which aims to establish recognition of works by Black Artists. . . . Whether or not these works portray the 'Black Experience,' or 'Heritage,' or are purely abstract is immaterial—so long as the works meet the highest standards exemplified in modern world art."

LOIS M. JONES '72

THE DEPRESSION AND THE WPA

Despite the interracial progress of the period, Blacks continued to hold an alien status. While the post-war period found them thriving in their own businesses in Harlem and working in all facets of industry, its allied trades, transportation, and communication, it remained remarkably more difficult for them to maintain employment than not. For as many who found employment, twice as many did not. Moreover, their rising numbers fueled an unreasonable fear in Whites who saw them as a threat to their thinly layered economic and social security.

As a consequence of this fear and resentment, Black-owned businesses were burned and vandalized. Trade, craft, and professional unions refused Blacks admittance, and in places where Blacks were hired, they were also the first fired. The prophecy born of White resentment of Blacks was in some ways self-fulfilling, as was the case when Whites went on strike: Blacks often crossed their picket lines and took their jobs in order to survive.

It is no wonder that Blacks experienced the effects of the Depression nearly a decade before it occurred in October of 1929. The economic collapse produced five times more unemployment in Harlem than in other sectors of New York City. The front-line struggle waged by Blacks for fair housing and employment intensified as even larger numbers of them headed northward. The Black League for Fair Play, which organized in 1933 to pressure White merchants to hire African Americans as clerks, launched an assault of boycotting and picketing that effectively gained them employment in stores in Harlem and with public-utility and bus companies.

While the success of such organized pressure benefited the jobless Blacks in Harlem, the many unemployed among them owed their financial relief to Roosevelt's New Deal public works projects. To be sure,

The Burning Bush

BEAUFORD DELANEY (1907–1979)

1941; oil on paperboard; 19⅞ x 24⅛ in. (50.4 x 127.3 cm). Gift of
Emilie Coles from the J. Ackerman Coles Collections, Mrs. Lewis B. Ballantyne
and Bequest of Louis Bamberger, The Newark Museum, New Jersey.

Although he studied at several art schools in Boston, Delaney considered himself to be self-taught. By 1929, he was living in New York, and in 1954, he moved to Paris, where he remained until his death. When interviewed about his reason for living in Paris Delaney said, "I belong here in Paris. I am able to realize myself here."

by 1939 millions of Blacks owed their living to the WPA, and like agencies of relief were surpassed only by agriculture and domestic service as sources of income for the Black population.

Three artist employment programs were initiated and implemented by the Works Progress Administration (WPA), which nurtured and fostered the creative development of American artists of African descent. The first was the Public Works Art Project (PWAP), which employed artists to create works for public spaces. The PWAP was akin to the government's contemporary Art in Public Places Program or state-administered One Percent for the Arts Programs. The subject matter of works created for the PWAP depicted the American way of life and were executed or placed in public buildings and parks.

Although the PWAP's tenure was brief, between its inauguration in December 1933 and its demise in May 1934 more than 3700 artists were provided with jobs. By placing art in public places the government introduced it to the masses, thus expanding their appreciation of art and establishing it as a laudable profession. This was particularly important for African American artists, as their participation in PWAP lent them credibility and the opportunity to tell their American story.

Joseph Delaney, Aaron Douglas, Sargent Johnson, Archibald Motley, Augusta Savage, and Hale Woodruff all received commissions under the PWAP. Sargent Johnson designed and made a redwood organ grill in 1934 for the California State School for the Blind in Berkeley; Hale Woodruff created a mural that same

Mending Socks

ARCHIBALD JOHN MOTLEY, JR. (1891–1980)

1924; oil on canvas; 43⅞ x 40 in.
(111.4 x 101.6 cm). Ackland Art Museum,
The University of North Carolina at Chapel Hill.
The social realism seen in this work is demonstrative of Motley's early style of painting. However, by the 1930s, Motley's social realism had given way to a colorful and spontaneous style of painting that focused on urban lifestyles and city dwellers, whose robust renderings teased the viewer with a kind of caricature.

year for the David T. Howard Junior High School in Atlanta, Georgia, called *The Negro in Modern American Life;* and Aaron Douglas completed the mural *Aspects of Negro Life* for the 135th Street Public Library in New York City. Their meager salaries ranged from $26.50 to $42.50 a week, but in those hard times this felt like a hundred dollars.[14]

The second artist-employment program commenced in October 1934, operated out of the Treasury Department, and was called the Section of Painting and Sculpture. It was also an art in public places kind of program, but unlike the PWAP, the Section of Painting and Sculpture was a competitive program. Its guidelines were immediately held suspect by African American artists and few if any of them received commissions. However, the larger community of White artists seemed equally excluded, so in May, 1935 the Federal Arts Project (FAP), the final employment program of the Works Projects Administration, was established to reach and include more artists.

The FAP was far-reaching in its funding of artists and arts organizations, exhibitions, mural and sculpture projects, art workshops, art production, art education, and research. Indeed, State of New York records suggest that at its height, the FAP employed more than five thousand artists and nationally produced 108,000 paintings, 18,000 sculptures, 2500 murals, and thousands of prints, posters, and photographs.[15]

Unlike with other WPA projects, African American artists served in FAP administrative positions. Augusta Savage, a sculptor and community activist working during this period, established several studios where she conducted art classes for Harlem children and youth. Through a grant from the Carnegie Foundation she was able to open her studio to any Harlem young person who wanted to study art. Moreover, she helped to organize the Harlem Artists Guild and a club called The Vanguard, which served to inform Black artists of the issues affecting them while encouraging solidarity and support of each others' struggles. Ms. Savage was an assistant supervisor on the WPA Federal Assistance Project in 1936 and her efforts went a very long way in helping African American artists prepare the proper documents and assemble the needed materials to receive grants and/or employment from the FAP.

Gamin

AUGUSTA SAVAGE (1892–1962)

1929; bronze sculpture; 16 x 18 x 6 in. (40.6 x 45. 7 x 15.2 cm).

The Howard University Gallery of Art, Washington, D.C.

One of the artist's few extant works, this sensitive and pensive sculpture won her a Fellowship to Paris. Savage made it possible for many people to take free art classes, and her former students include such artists as Ernest Critchlow, Normal Lewis, and William Artis.

Wanted Poster Number 4 (Sara)

CHARLES WHITE (1918–1979)

1969; oil on composition board; 24 x 24 in. (61 x 61 cm). Purchase with funds from the Hament Corporation, Whitney Museum of American Art, New York.

White, a prolific printmaker and painter, produced direct and clear images that focused on Black life, history, and culture. Making a strong historical and contemporary statement, *Wanted Poster Number 4 (Sara)* was included in the Whitney Survey of Contemporary Black Artists.

COMMUNITY-BASED PROGRAMS

The community-based art programs that subsequently appeared in African American communities across the country were funded all or in part by the FAP. Indeed, in Richmond, Virginia an alternative arts workshop replaced the public school's segregated art program from which African American children were excluded. FAP funds also provided technical assistance to the 135th Street YWCA so that it could broaden its arts and crafts program. Youth, ages ten to seventeen, were taught sculpture by the artist William Artis and the most successful works were exhibited at the New Jersey Museum in Trenton.

The Harlem Community Art Center, which was established with FAP funds, opened in 1937 and served as an FAP model for other community art centers across the country. Eleanor Roosevelt was present at its opening and Augusta Savage served as its first executive director. It introduced and advanced the art education of thousands of Harlem's children, youth, and adults.

Through still other funds from the FAP, the Karamu House, a neighborhood settlement house in Cleveland, Ohio, was able to hire professional artists to teach its Black students, thus enriching its offerings to the children and youth of the community it served. And, when its original building was consumed by fire in 1939, a fund-raising campaign sponsored by the Associated American Artists Galleries in New York, with Eleanor Roosevelt as its honorary chair, exhibited Karamu artist's works.

Chicago's South Side Community Art Center, which was also able to benefit from FAP funding, opened its doors in 1940. However, unlike the Harlem Community Art Center, South Side did not rely solely upon FAP funding. In its independent fundraising efforts, the center was able to establish an alternative funding base, allowing it to survive beyond the demise of the FAP in 1943. The center's art program was advanced by such well-known artists as Charles White, Charles Sebree, Gordon Parks, and Margaret Burroughs, who would later establish the DuSable Museum.

In addition to community arts centers, the presence of arts and crafts programs in public schools significantly exposed the public to the work of African American artists through their cultural educational programs. For instance, Roosevelt High School in Gary, Indiana opened its own art gallery. Howard University, where Alain Locke taught, offered training in studio and art history and sponsored, received, and traveled exhibitions. The Atlanta University System, then including Spelman College, Morehouse College, and Atlanta University, hired the artist Hale Woodruff in 1931 to teach and expand the University's art course offerings, generally taught at Spelman College. The University's gallery opened in 1932 and, like that of Howard University, also received, mounted, and traveled important exhibitions.

In April 1942 Woodruff established the Atlanta University annual art exhibitions which were held until April 1970.[16] Through these exhibitions Atlanta University was able to amass a collection of African American art as prestigious as those of Howard and Hampton universities. The annual exhibitions, like those of the Harmon Foundation, encouraged African American artists to develop a representational art that was based on their African heritage and culture.

The Blue Jacket

CHARLES SEBREE (1914–1985)

1938; oil on canvas; 30 x 24 in. (76.2 x 60.9 cm).
Evans-Tibbs Collection, Washington, D.C.

Sebree, a Chicago-based artist, was an important part of South Side Chicago's 1930s art scene. He created *The Blue Jacket* during his tenure as a WPA Easel Division artist from 1932 to 1938. Moving to New York in the 1940s, Sebree folded neatly into the visual art scene and illustrated Countee Cullen's book *The Lost Zoo.*

Reflections

HUGHIE LEE-SMITH (1914–)

*1957; oil on canvas. Evans-Tibbs
Collection, Washington, D. C.*

Placed on a desolate beach,
the lone figure appears
isolated and alienated.
The open expanse of space
surrounding the subject
lends a surreal perspective
and suggests psychological
and emotional desolation.

The Flight Into Egypt

JAMES LESESNE WELLS (1902–)

1930; oil on canvas; 19½ x 23½ in. (49.5 x 59.6 cm).

Hampton University Museum, Hampton, Virginia.

Essentially known as a printmaker, Wells' early career was based on such paintings as *The Flight Into Egypt* and others, which won for him cash awards and recognition. His subjects were diverse and included religious and African themes. In the early 1930s Wells began exploring the graphic arts, lithography, block printing, and etching.

BETWEEN THE WARS

The art of the African American matured considerably from the period of the Harlem Renaissance to the 1930s and 1940s. Indeed, Alonzo Aden of the Howard University Art Gallery organized the exhibition *Art of the American Negro (1850–1940)* with the financial support of the Harmon Foundation and the WPA, for the 1940 American Negro Exposition in Chicago. The exhibition recognized the works of such young artists as Lois Mailou Jones, Jacob Lawrence, Eldzier Cortor, Hughie Lee-Smith, and others. So successful and well received was this exhibition that Aden opened the Barnett Aden Gallery in his mother's home in Washington, DC.

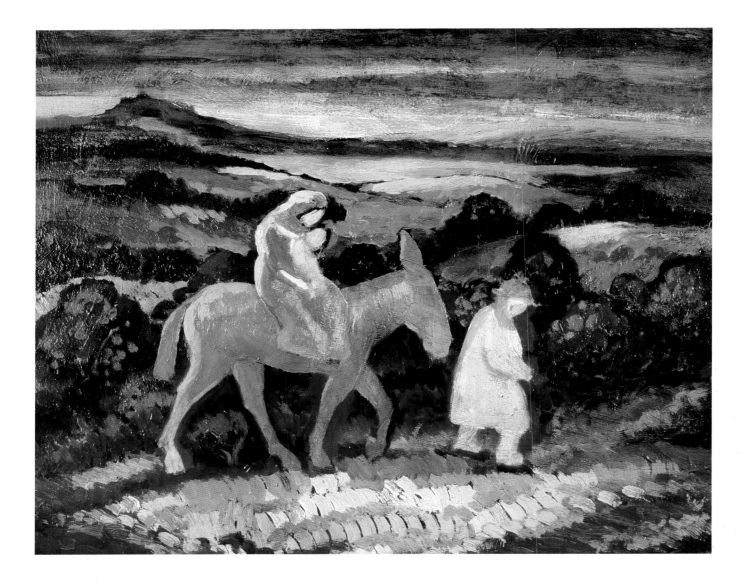

Equally important, however, is the fact that this exhibition encouraged Alain Locke, artistic ombudsman of the Renaissance, to reconsider some of the positions put forth in his 1936 publication, *Negro Art: Past and Present,* in his 1940 revised edition called *The Negro in Art: A Pictorial Record of the Negro Artists and the Negro Theme in Art.* The revised edition recapitulated much of the content from his essays from the Renaissance but, significantly, also included photographic reproductions of art by Americans of African descent beginning in the 1700s. A component on the ancestral arts and the Negro theme in European and American art was also included.

The last major exhibition of African American artists of the 1930s and 1940s, *The Negro Artist Comes of Age,* was organized in 1945 by the Albany Institute of History and Art of Albany, New York. The exhibit, sponsored by the Carnegie Corporation of New York and the Phelps-Stokes Fund, included the works of forty-three artists representing styles ranging from abstract to Social Realism—and was accompanied by a catalogue with an essay by Alain Locke.[17] The works in this exhibition expressed a Black aesthetic whose language embraced elements from the African past and from the Black communities of which they were a part.

In the years following World War II, interest in the plight of the African American artist waned, as did all-Black exhibitions. While certainly the network of community- and college-based exhibition spaces—Howard University Art Gallery, Atlanta University, Barnett Aden Gallery—continued to offer exhibitions by African American artists and others, Americans both Black and White began to focus on a larger platform of social and political needs. Thus, the cultural and artistic concerns of Black artists fell to the wayside, especially after the passing of the 1954 Supreme Court desegregation decision, Brown vs. the Board of Education.

The decision inaugurated the civil rights movement and provided it with both visibility and credibility not previously had. The movement sought to reverse discriminating policies and practices in employment, housing, and education that restricted the quality of life for Americans of African descent. However, many Black artists would be active participants in the civil rights movement. Their participation would branch off into a Black Art Movement that demanded inclusion in the artistic mainstream as it struggled to define the role of the African American artist.

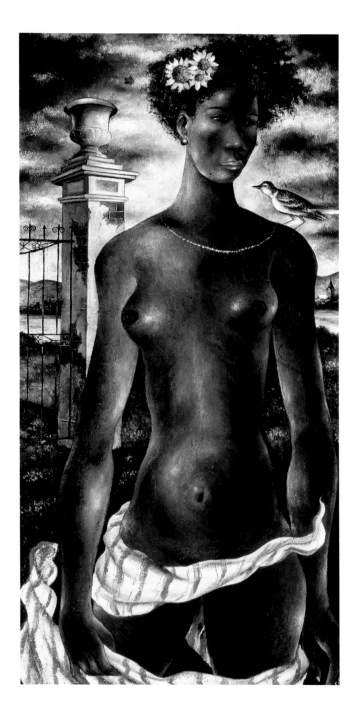

Southern Gate

ELDZIER CORTOR (1916–)

1942–43; oil on canvas; 46½ x 22 in. (117.5 x 55.8 cm). Gift of Mr. and Mrs. David K. Anderson, Martha Jackson Memorial, National Museum of American Art, Smithsonian Institution, Washington, D. C.
Deeply interested in Black life and culture, Cortor traveled to the American South, Jamaica, Cuba, and Haiti to broaden his perspective. The artist has stated that his handling of the human figure is in keeping with the cylindrical and lyrical qualities of African sculpture.

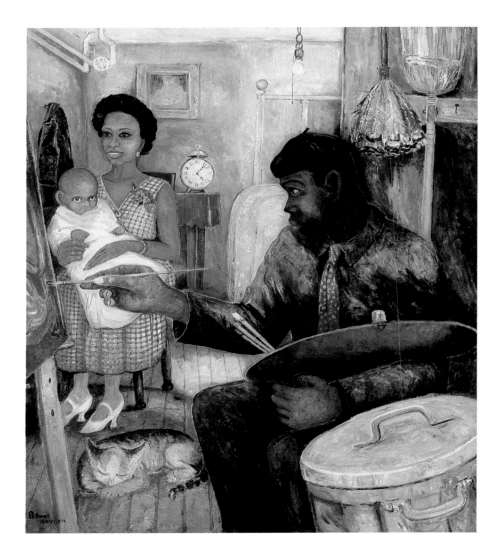

The Janitor Who Paints

PALMER HAYDEN (1893–1973)

c. 1937; oil on canvas; 39 1/8 x 32 7/8 in. (99.3 x 83.5 cm).

National Museum of American Art, The Smithsonian Institution, Washington, D. C.

First exposed to the arts through a correspondence course, Hayden later
moved to New York where he studied under artist and Cooper Union
instructor Victor Perard. After winning a Harmon Foundation cash award
in 1926 the artist traveled to Paris, where he began painting Black subjects.

The Kiss

MARION PERKINS (1908–1961)

1948; white marble sculpture; 11 x 20 x 2 in. (27.9 x 50.8 x 5 cm).

Evans-Tibbs Collection, Washington, D. C.

Influenced by the tenets of the Harlem Renaissance, Perkins looked to African
art for direction and its expressive influence runs through his sculpture.

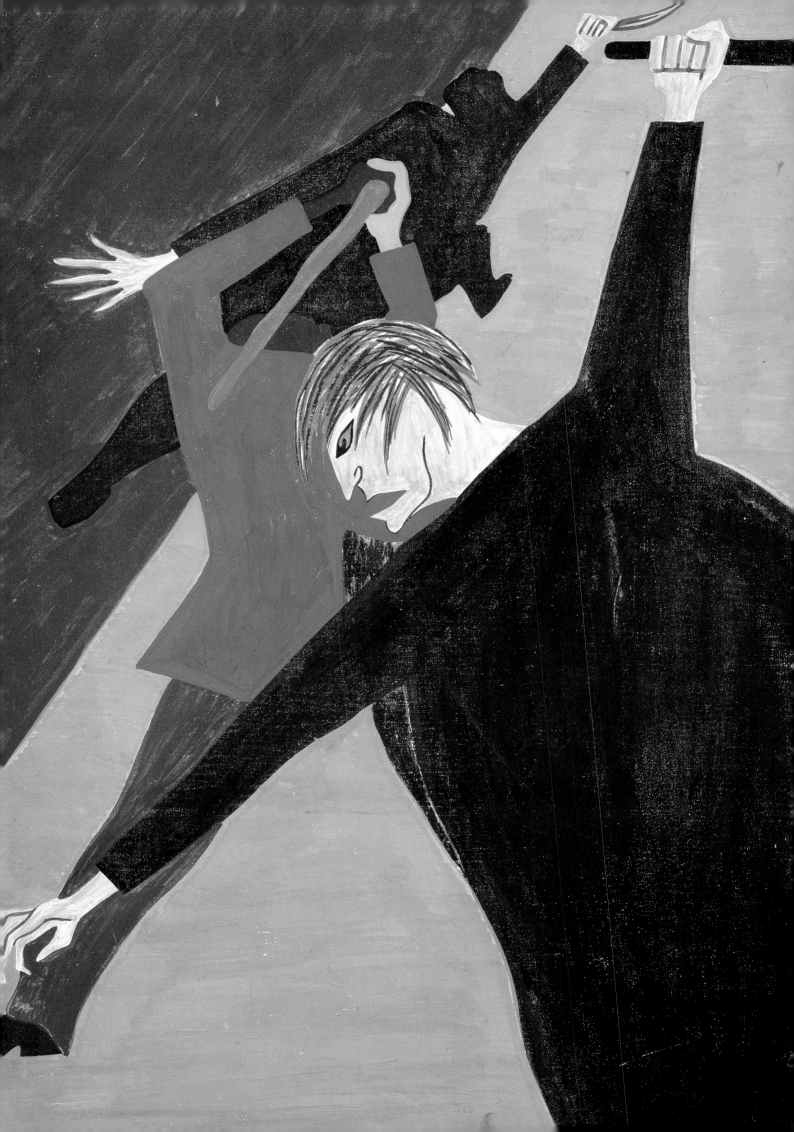

**The Migration of the Negro
(Panel 50: "Race riots were very
numerous all over the North . . .")**

JACOB LAWRENCE (1917–)

1940–1941; tempera on composition board; 18 x 12 in.

(45.7 x 30.4 cm). The Museum of Modern Art, New York.

This Series pertains to the Black migration from
the South to the North after World War I, but shows
that the conditions that they met in the North were
similar to those that they had known in the South.

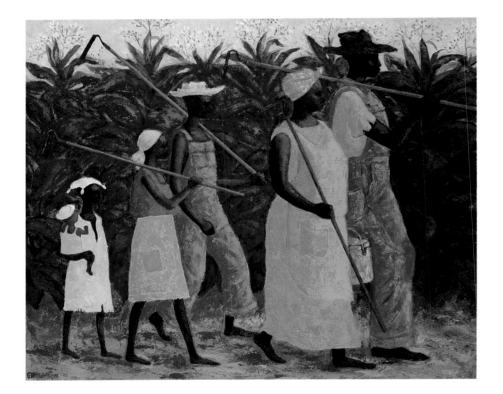

Field Workers

ELLIS WILSON (1899–1977)

n.d.; oil on masonite; 29¾ x 34⅞ in. (75.5 x 88.6 cm). National
Museum of American Art, Smithsonian Institution, Washington, D.C.
Colorfully rendered abstract expressionistic
landscapes and figurative compositions dominate
Wilson's works. His research took him to the
West Indies, Africa, and the American South, all
in an effort to better render Black life and culture.

A Celestial Gate

HALE WOODRUFF (1900–1980)

c. 1967; AP serigraph, ed. 200; 22⅝ x 30 in.
(57.4 x 76.2 cm). Spelman College, Atlanta, Georgia.
The Celestial Gate Series emerged at a time
when African American artists were struggling
with their identity and the form and content
of their work. Woodruff combined layers of
an Abstract Expressionist-derived style with
Africanesque symbols to produce culturally
familiar works that also have mass appeal.

The Living Room

ROMARE BEARDEN (1940–1987)

1978; collage and mixed-media on board; 6½ x 8½ in. (16.5 x 21.6 cm).

Sheldon Ross Gallery, Huntington Woods, Michigan.

Though Bearden's works explore many aspects of urban
and rural Black life, they often focus on the myth and ritual
of the American South. Women hold a central position and
are presented as healers, conjurers, and mothers. Bearden's
abstract expressionist approach folds into his use of collage,
creating stunning views and perspectives of Black life.

THE MID-1950s TO THE PRESENT DAY

The cultural life of the Black artist was greatly enriched by the Harmon Foundation, the patronage and exhibition networks established during the Harlem Renaissance, and the work-relief programs of the Works Progress Administration. But by the 1950s, these sources of support disappeared, as had the Black artists' visibility. As racial tensions rose, some artists— Ed Clark, Beauford Delaney, William T. Williams, Sam Middleton—left the United States for Europe, where they felt they could pursue their art and be treated humanely. They melted into that colony of African American artists—Paul Keene, James Baldwin, Richard Wright, Herb Gentry—living abroad. The vast majority, however, remained in the United States. And, though a few such artists as Romare Bearden, Norman Lewis, and Jacob Lawrence continued to be shown by major museums and galleries, they were the exception rather than the rule.

THE CIVIL RIGHTS MOVEMENT

Increasingly, the friends and allies of African Americans sought to establish social and political standards that eliminated their excluded status. Thus, it was a tremendous victory for Blacks and their burgeoning civil rights movement when, in 1954, the Brown vs. the Board of Education decision outlawed segregation in public schools. The impact of this decision was brought to the attention of the entire nation when, on February 1, 1960, four college students from Greensboro, North Carolina sat down at a segregated lunch counter in Woolworth's, one of the largest chains of five-and-dime stores in America, to order coffee.

To be sure, the heroic deeds of the Greensboro four ignited student sit-ins across the South and led to the establishment of the Student Nonviolent Coordinating Committee (SNCC), a national multiracial student organization whose members became the front-line foot soldiers of the civil rights movement. These young warriors infiltrated Southern Black communities to build self-esteem, boost cultural confidence, and conduct leadership development workshops, sit-ins, marches, and voter-registration drives. By 1961 their efforts were augmented by the Congress of Racial Equality (CORE), which sent integrated bus loads of young people, called Freedom Riders, throughout the South to challenge interstate segregation laws and practices.

Then, in August 1963, hundreds of thousands of Blacks and Whites from across the nation, chanting "Free by '63," participated in the Poor People Campaign's March on Washington for Jobs and Freedom. During the nationally televised event, more than 300,000 marchers gathered in front of the Lincoln Memorial in Washington, DC, calling for an improved quality of life in African American communities and the creation of opportunities for its members who had long been socially, economically, and educationally disinherited from the American way of life. Thus, the civil rights movement became the voice of Black America, first focusing on segregation and voting rights, then later on jobs, housing, education, and welfare.

NORMAN LEWIS, ROMARE BEARDEN, AND SPIRAL

The sweeping social change and political unrest brought on by the civil rights movement of the 1960s equally impacted African American artists. They met in groups to talk about their role and status within the society, their influence as artists, the function of their art, and its visual language and aesthetic. *Spiral*, one of the earliest such groups, was founded in 1971 by Romare Bearden and Norman Lewis. Of its fourteen members, Emma Amos was the only female. They "discussed whether or not there was any such thing as Black art and debated the role the Black artist should

Heavy Forms

BOB BLACKBURN (1922–)

1961; lithograph; 16 x 20 in. (40.6 x 50.8 cm). Courtesy of the Artist.

A master printmaker, Blackburn was a student at Augusta Savage's Harlem Art Center, and it was there that he was introduced to lithography. A student of the Art Students League, he later established (in 1948) the Printmaking Workshop, where he has served as artist and teacher for some five decades.

play in the Movement [and considered] if they shared qualities that could be transmitted through their art."

Norman Lewis, who had belonged to a collective of artists in the 1930s, believed art should be used to promote social change. He was born in New York and attended the WPA-funded Harlem Art Center (directed by Augusta Savage) where he met and established long friendships with Bearden, Beauford Delaney, Charles Alston, and others. By the 1960s, however, Lewis felt that the "political and social aspects should not be the primary concern of the art but rather that esthetic ideas should have preference.[18]

Bearden's ideas were somewhat similar. He felt that painting the "ritual of Negro life can provide the same formal elements that appear in other art, such as a Dutch painting by Pieter de Hooch."[19] Issues concerning aesthetic standards had long been an interest of Bearden's. He worried that the Harmon Foundation exhibitions fostered mediocrity because they encouraged artists to explore an art of racial identity. Ultimately, Bearden found that exploring one's racial identity did not diminish the art; in fact, his doing so had caused him to reevaluate who he was and what his art was intended to produce for himself and those

experiencing it. As if having completed a twelve-step program that reoriented his vision, Bearden gradually developed a style of work that evolved into narrative voyages populated by bits and pieces of figurative images that informed both the past and present. Bearden's choppy photocollages of the 1960s and 1970s were the visual metaphors of struggle—both the African American's and the Black artist's.

Born in North Carolina, Bearden grew up in Harlem. His mother was a journalist and his father, a civil-service worker. He graduated from New York University with a degree in mathematics. Employed by the New York Department of Social Services, he took evening courses at the Art Students League. He was a member of the Harlem Artists Guild, where he met Charles Alston, Aaron Douglas, and others. Through his involvement with this artists' association, Bearden came to understand the importance of the WPA and the function its programs served in perpetuating the growth and development of Black artists.

Bearden was also a member of the 306 Group. This collective of artists—Jacob Lawrence, Bob Blackburn, Norman Lewis, Ernest Critchlow, Augusta Savage, Aaron Douglas—musicians, writers, poets, and performance artists from various cultural and ethnic backgrounds—met in Charles Alston's Harlem loft and played an important role in Bearden's development and his commitment to being an artist.

Bearden began having one-man showings in mainstream galleries as early as 1945. In the 1950s he went abroad to France to study philosophy; while there he met artists and writers and toured the museums. When he returned to his studio above the Apollo Theater in Harlem, he was unable to paint for two years. But by the 1960s, Bearden returned to figurative work and was experimenting with the enlargement of photostatic images which led to his mixed-media collage-paintings, the principal language of his visual-arts signature.

ELIZABETH CATLETT

Though Elizabeth Catlett was not affiliated with any particular group, she had always engaged in struggle. By the 1960s she had become recognized as an important printmaker, sculptor, and political activist. She

Tired

ELIZABETH CATLETT (1919–)

1946; terra cotta sculpture; 13½ x 5 x 8 in. (34.2 x 12.7 x 20.3 cm).

The Howard University Gallery of Art, Washington, D. C.

"Art must be realistic for me, whether sculpture or print-making. I have always wanted my art to service Black people—to reflect us, to relate to us, to stimulate us, to make us aware of our potential . . ."

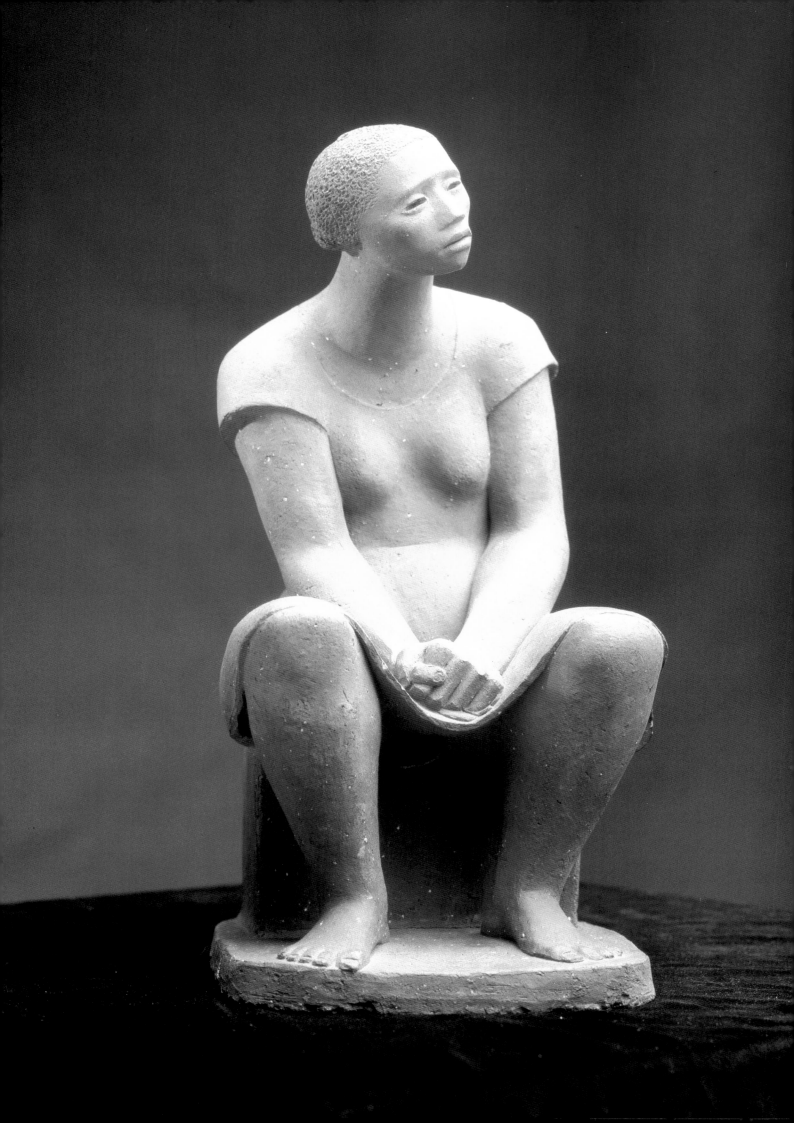

Oppression Anywhere
is Oppression Everywhere

WILLIE BIRCH (1942–)

1992; mixed media, papier mâché; 14.5 x 16 x 7 in. (36.8 x 40.6 x 17.7 cm).

Arthur Roger Gallery, New Orleans, Louisiana.

Birch narrates the circumstances impacting upon daily life. He has remained true to form—just as his mural and other two-dimensional works of the 1960s and afterwards informed the Black community about the unordinariness of their daily lives, so now do his three-dimensional works, which are encoded with an African iconography replete with metaphysical references.

was as convinced in the 1940s as she was in the 1960s that "the job . . . [of the Black artist] was to look into . . . Black communities for inspiration—to work for . . . Black people—and to show the link between our struggle and that of similarly warped and oppressed people. We have to create an art for liberation and for life."[20]

Catlett was born in Washington, DC. She attended Howard University, the first Black College with a department of art. There, she studied under James A. Porter, Lois Mailou Jones, and James Wells. Black subjects in general and women in particular have always dominated Catlett's sculptures, prints, and drawings. In fact, one of her earliest fellowships went toward developing a body of work devoted to women. Graduating in 1937, she left Washington to teach high school in Durham, North Carolina, and while there joined a struggle to equalize teacher's salaries. Catlett

received her Master of Fine Arts degree in 1940 from the University of Iowa. The following year she married the artist Charles White; they moved to New York City and lived in Harlem. While there Catlett worked in a WPA-sponsored alternative community school for adults, thus meeting her perception of the visual artist as a cultural worker.

Even though their marriage was troubled, the Whites visited Mexico in 1946. The time spent there was artistically productive for their careers but the marriage was unsalvageable. After the couple's separation, Catlett returned to Mexico, and married the Mexican artist Francisco Mora in 1947. Both artists were politically active, and Catlett, along with other American artists living abroad, became the prey of Joseph McCarthy's House Un-American Activities Committee. Indeed, she was accused of being a member of the Communist Party and arrested as an undesirable alien. Even though she subsequently gave up her American citizenship in 1962 to become a Mexican national, the US government continued to harass her by refusing to allow her entry into the United States. Catlett's treatment did not go unnoticed by American Black artists. They rallied to her support, and by the early 1970s the government had restored Catlett's U.S. visa privileges.

THE BLACK ART MOVEMENT

The widespread consideration of the issues and questions raised by these and other African American artists from across the country spontaneously generated the Black Art Movement. Not just a response to the social and political turmoil, the Black Art Movement was also part of a general awakening and raising of national consciousness that was affecting Blacks, Whites, Asians, and Latinos. The movement helped Indians, Asians, and Latinos who "used to go along with the white . . . view in which [they] were a couple of notches above Black people from Africa and the Caribbean . . . realize that was just a divide-and-conquer tactic . . . [and that] we must all stand together as Blacks."[21] Thus, by identifying with the issues of Black artists, many different people of color and groups in similar sociopolitical situations bonded together to struggle collectively for parity.

Moreover, the Black Art Movement and the ideas it espoused spawned an African American art which amplified the social and political inequities previously seen in the art produced by the Social Realists of the 1930s and 1940s. The direct and forceful statements of social protest made by the works of Bearden, Lewis, Catlett, Willie Birch, Ray Saunders, and others in the 1960s and 1970s served to educate the public about the impact of America's oppression and damage upon the African American psyche.

To this end, American symbols of democracy and fairness were held up as mirrors of repression, racism, and sexism. In particular, the American flag came to stand for all of America's ills and African American artists began to use it as the quintessential symbol in a new and complex political art, though the American government's response to such a use was harsh. Indeed, when Faith Ringgold, along with two White male artists, Jon Hendricks and Jean Toche, organized the People's Flag Show (1970) at the Judson Church in New York, which included more than two hundred artists, to protest against American oppression and repression at home and abroad and its repressive laws governing the use of the stars and stripes in art, they were arrested and found guilty of desecrating the American flag.[22] This action did not, however, stop artists from continuing to use the flag as the First Amendment later assured they could.

FAITH RINGGOLD

Faith Ringgold had been using the American flag as a symbol of protest in her work since 1964. In her paintings it was used as the backdrop for riots, murder, and mayhem. In *Flag for the Moon: Die Nigger* (1969), "an irregularly striped flag fills the canvas; when the painting is given a half-turn to the right, the stripes spell 'NIGGER.'"[23] The meaning of Ringgold's paintings during this period were particularly poignant especially when you consider that she was denied admittance into Spiral and exhibition privileges at the "Studio Museum in Harlem in 1969 and 1970 because there were all these Black male artists who would have to get their chance first."[24]

The Black cultural nationalists embraced the notion that women should remain appropriately behind men. Responding to this sexism and chauvinism, Ringgold, Kay Brown, and Dingda McCannon founded *Where We At Black Women* in 1971, a women's artists group which sought to find exhibition opportunities for Black women. Although Ringgold's membership with the group was short-lived, she would continue to organize women into collectives throughout her career.

Born and raised in Harlem, Ringgold was a graduate of the City College of New York and an artist activist in both the women's and Black Art movements. As such, she stood as an important Black artist with a feminist voice who was increasingly being heard. Her works examined the position of women in society; an early example is the mural *For The Women's House*, which she created and installed for the Women's House of Detention on Rikers Island, New York. In her *American People Series*, she attacked the "social pretensions and hypocrisies of Black and White Americans

and the bogus camaraderie of integration."[25]

Ringgold also created a series of soft-sculpture installations that dealt with social commentary and criticism and traveled easily to college campuses and other sites. These works allowed her to maintain and develop a national dialogue with her audience, which was comprised of ethnically diverse students and others. She was constantly working on raising the consciousness of students, and led the organization Students and Artists for Black Art Liberation (SABAL) in a protest centering around the exclusion of female

Jack Johnson

RAYMOND SAUNDERS (1934–)

1971; oil on canvas; 81¾ x 63½ in. (207.6 x 161.2 cm).

The Pennsylvania Academy of the Fine Arts, Philadelphia.

Saunders was the first Black artist to receive the Prix de Rome, which enabled him to study at the American Academy in Rome for one year. His abstract expressionist works are studded with bright primary colors, creating a rich and exciting feeling.

Die

FAITH RINGGOLD (1930–)

1969; oil on canvas; 3 ft. x 4 ft., 2 in. (.91 x .65 m). Courtesy of the Artist.

Artist, educator, organizer, and author, Ringgold has spent her career developing options for women in the arts. Her struggle to achieve parity has landed her in jail and outside the mainstream. But her inventiveness in working with dolls resulted in a broadening of her audience and the movement of her work across the country. Combining her painting abilities with her soft sculptural talents, Ringgold now creates story quilts which borrow technical and aesthetic aspects of her career in the visual arts.

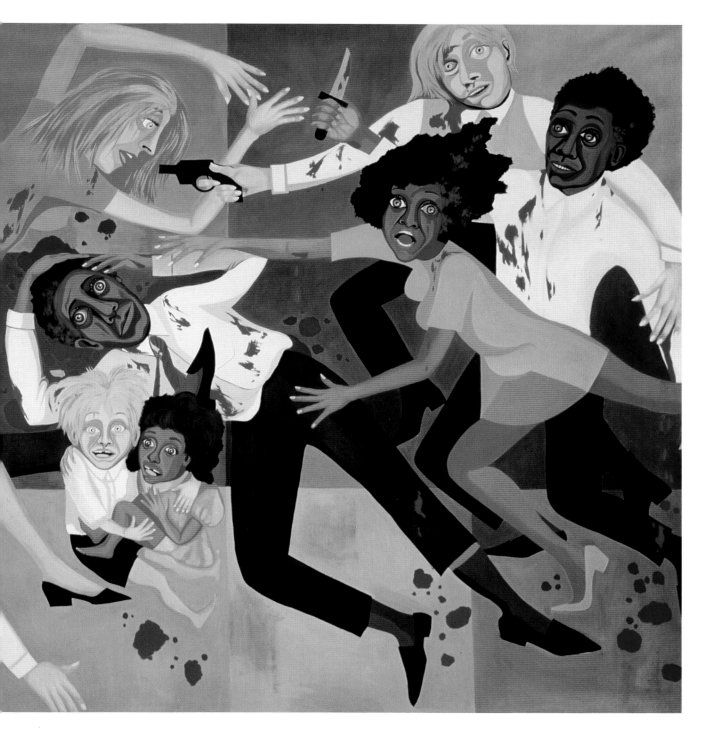

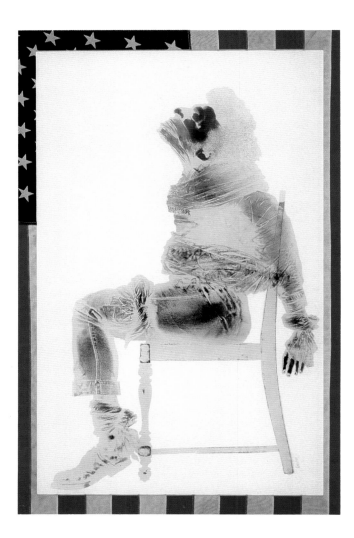

and Black artists, against the Venice Biennale show at New York's School of Visual Arts.

In the 1980s Ringgold began working on mixed-media story quilts which combined painting, quilt-making, and storytelling. They are both public and private documents, and according to Lucy Lippard, "Ringgold performs the griotte's function in the domestic materials of story and cloth, telling dramatic tales of foreign wars and city street life, slavery and resistance, passion and greed, jazz and the Harlem Renaissance, murdered children in Atlanta, family intrigue and tragedy, all painted with compassion, humor, and often anger in a proud vernacular tradition."[26] Ringgold has used narratives from her story quilts to produce children's books, of which one of the most acclaimed is *Tar Beach*.

THE BLACK EXPERIENCE IN MANY MEDIA

David Hammons, who emerged in the 1960s as a mixed-media artist, created a visual language that used hair, bottles, bottle caps, other found objects, and popular symbols such as the flag in his installations and body prints to make a social, political, or cultural statement about Black life in America. Both his installations and works on paper are like still-life performances, frozen frames, in a silent visual movie to which the viewer adds the sound. Hammons felt it was his "moral obligation as a Black artist to try to graphically document what [he felt] socially." In 1970, he produced, among other works, a body-print silk-screen called *Pray for America*, in which a Black man shrouded

Injustice Case

DAVID HAMMONS (1943–)

1970; mixed media body print; 5 ft., 3 in. x 3 ft., 4½ in. (1. 6 x 1.37 m).

Art Museum purchase, Los Angeles County Museum of Art, California.

Hammons' installations of collected and other objects found in the Black community and works on paper are welded into the social and political lifestyle of Black people. In his body prints, the body serves as the actual printing plate and in the transfer to a paper surface is purposely distorted as part of the statement.

The Liberation of Aunt Jemimah

BETYE SAAR (1926–)

1972; mixed media; 11¾ x 8 x 2¾ in. (29.8 x 6.9 cm). Photograph by Colin McRae. Purchased with the aid of funds from the National Endowment for the Arts, The University Art Museum, University of California at Berkeley.

The social, political, and spiritual terrain of Saar's work incorporates found objects, personal family memorabilia, and other materials. In this work, using the familiar and derogatory image of Aunt Jemimah, Saar transforms the stereotype into a reactionary revolutionary carrying a gun.

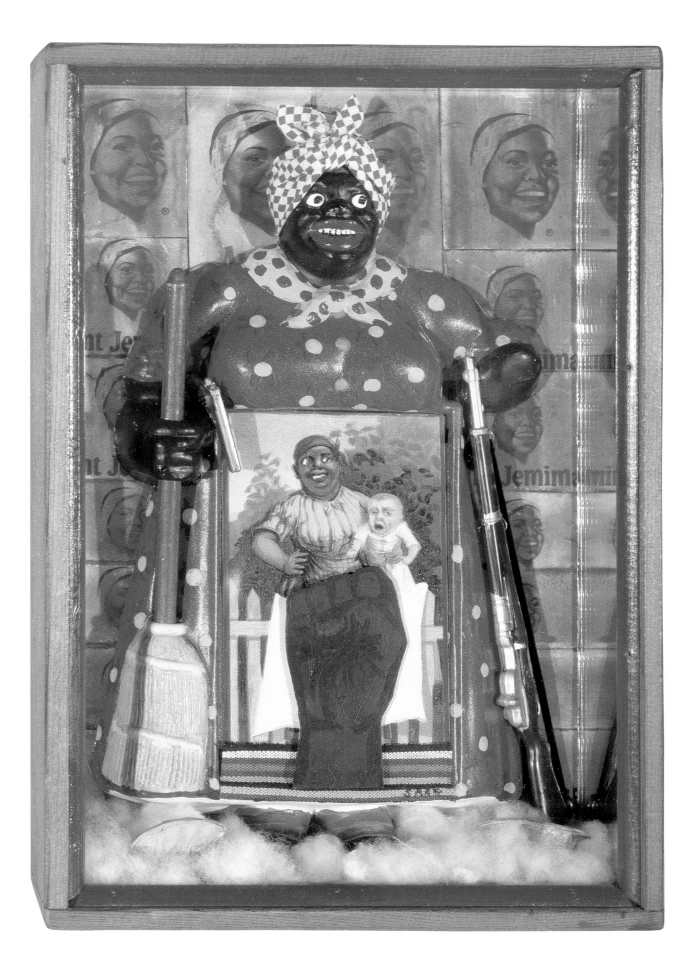

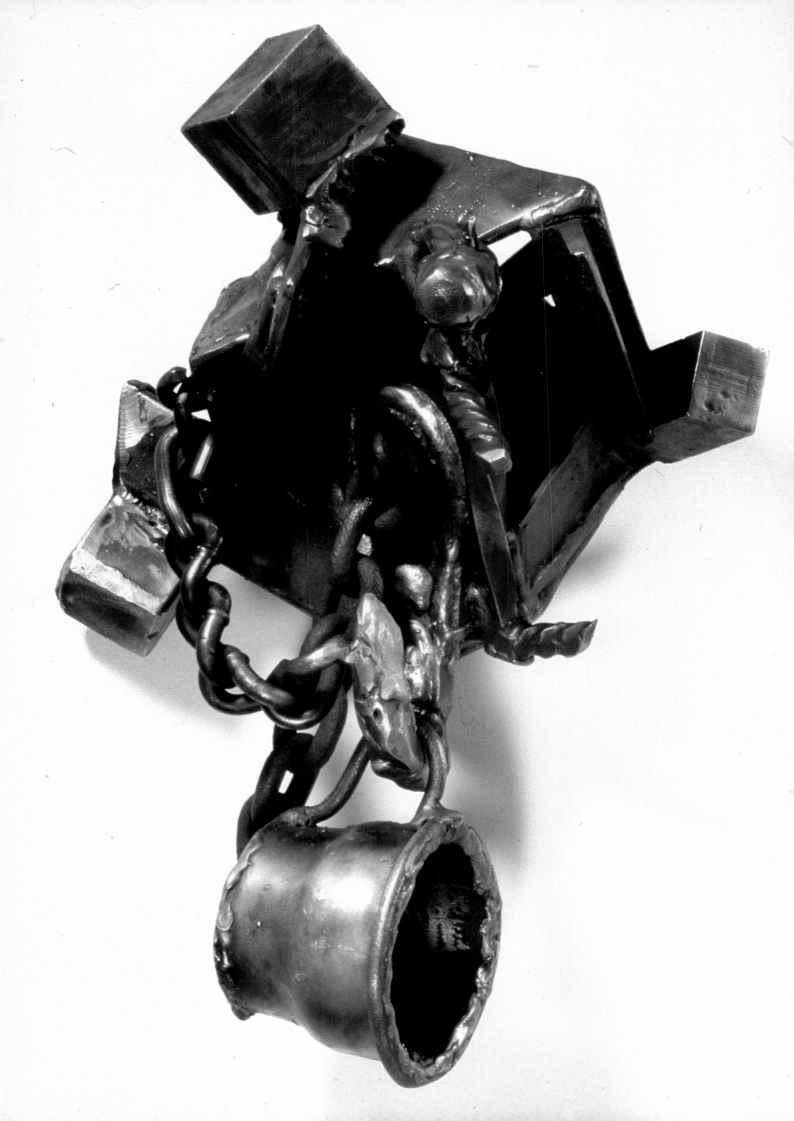

in the American flag is praying. Similarly, Dana Chandler's 1971 *Genocide* series cast the American flag as prison bars to symbolize its repression and genocidal practices.[27]

Betye Saar, on the other hand, incorporated derogatory commercial images to expose the racism they conveyed. A California-based artist, Saar was one of the first Black women to exhibit at the Whitney Museum of American Art in New York. Saar's work is a narrative journey that infers relationships between real and imagined states of being and accumulates its meaning through the objects and items that compose it. Her work tackles spiritual and metaphysical concerns that are aired like laundry through her imaginative use of found and recycled objects, which themselves possess a consciousness. In her *Liberation of Aunt Jemima* (1973), the well-known symbol in a line of food products is transformed into a gun-carrying warrior for Black liberation.[28]

In addition to the use of universally meaningful and popular symbols to expose America's racism and/or sexism, African American artists also employed images that were more directly specific to their unique historical experience. For instance, in 1963 Mel Edwards began producing a series of sculptures using wire and metal, allegedly collected from the Watts riot, that was partially covered in chains and focused on the lynching of African American men and women. Called the Lynch Fragment Series, his intention was to "remind Black people of what we have come out of. That's important because in the United States we're the only people to actually come out of the lynching experience . . . Basically being lynched belonged to us . . . We were the only people who could be lynched with impunity. It's documented and it's not over yet."[29]

Fire Blossom

MEL EDWARDS (1937–)

1991, Lynch Fragment Series; steel, 18 ft. (5.49 m). Courtesy of the Artist.
"The Fragments appeared in 1963. I stopped making them in 1966 to emphasize other ideas. Because of a couple of incidents in 1973 I made a dozen or so, as a statement. More were made in 1978 for my Studio Museum in Harlem exhibition and I have never stopped."

THE MURAL IN AFRICAN AMERICAN ART

The Black Art Movement produced a visual language popularly called "Black Art" that specifically referred to an art of liberation. It protested injustice and produced freedom messages for a people enslaved by colonial ideas. The art was integrally tied to the people and joined them in a mutual struggle for change. Some of the art produced during this period by such artists as Saar, Hammons, Bearden, Edwards, Ringgold, and others projected its message in conceptual and abstract terms. On the other hand, another form of Black Art, the mural, also emerged at this time.

Functioning as political and historical storyboards, murals stood as sentinels in a uniform of primary colors scattered throughout the Black community. The mural's figurative and narrative quality made its celebration of various aspects of the African American experience easily understood. Almost always on building walls out-of-doors, they legitimately served as the public art of the Black Art Movement.

The *Wall of Respect* mural in Chicago (1967) was the first of these public works; it was created in 1968 by a coalition of artists, musicians, and writers called AFRI-COBRA (African Commune for Bad Relevant Artists). The group included such artists as William Walker, Jeff Donaldson, Wadsworth Jarrell, Carolyn Lawrence, Barbara Jones, Napoleon Henderson Jones, Nelson Stevens, and Frank Smith. It "fused W.E.B. DuBois' ideas about propaganda and art with Alain Locke's concern for a culturally rooted art into a program designed to make their art more accessible to working-class and poor Blacks, both in terms of its level of presentation, availability and cost."[30] The *Wall of Respect* includes African America heroes—Muhammad Ali, W.E.B. DuBois, Charlie "Bird" Parker, Stokley Carmichael, Sarah Vaughn, Thelonious Monk, Gwendolyn Brooks, and others—who are revered and highly respected within the culture. It was accessible to the masses and its easily understood visual language "advocate[d] social change and champion[ed] the politically, economically and socially disadvantaged."[31]

The *Wall of Dignity* mural, as well as an unnamed one at the corners of Massachusetts and Columbus avenues in Boston—created by Gary Rickson and Dana

Latter Day Saint Sebastian (Cruelty and Sorrow Series)

BENNY ANDREWS (1930–)

1993; oil and collage on canvas; 72 x 50 in.

(182.8 x 237 cm). Courtesy of the Artist.

Deeply committed to the plight of Black people in America, Andrews' art is drenched in social comment and has always functioned to amplify the social and political issues disenfranchising the African American. An outspoken ombudsman for change, Andrews organized the Black Emergency Cultural Coalition, which protested against mainstream art institutions and organizations excluding African Americans.

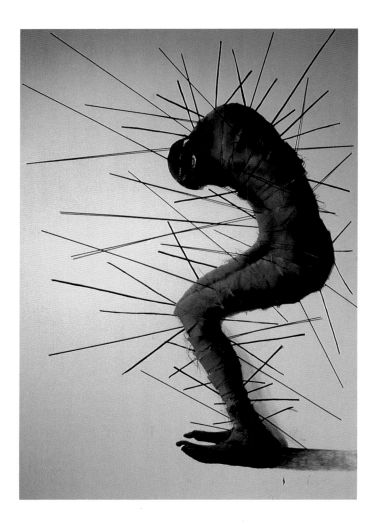

Chandler—followed in 1968. The murals not only made political connections between race, war, and oppression but also mirrored pride and reinforced self-determination and empowerment while exampling the achievements made by African Americans.

PROTESTING THE WHITE ART ESTABLISHMENT

Artists gradually began to see a connection between museum policies and practices and certain political issues like American investments in South Africa and apartheid, and support of the Vietnam war and racist and sexist behavior towards African Americans and women artists. In an effort to change and expose the duplicitous behavior of the museums' leadership toward women and Black artists, the Black Emergency Cultural Coalition (BECC), organized in 1969 by Cliff Joseph, Benny Andrews, and Valerie Maynard, waged a multiracial attack against such New York–based museums as the Museum of Modern Art, the Whitney Museum of American Art, and the Metropolitan Museum of Art. BECC "members were not just the politically conscious minority that had been speaking out for several years, but a truly heterogeneous mixture of artists of all ages and races."[32]

Their complaints focused on the museums' lack of Black scholars and curators and exhibitions by American artists of African descent. The coalition meant to upset the prevailing racist and discriminatory attitudes, provide African American artists entrée to museum venues and audiences, and re-educate the museum professional and the public about the contributions of African American artists to the art historical record.

Send the Message Clearly

VALERIE MAYNARD (N.D.)

Lithograph on Rives paper. Brandywine commission. Courtesy of the Artist.

Principally a sculptor but also a printmaker, Maynard emerged as an artist in the 1960s as an active participant in the Black Art Movement, along with such other artists as Ringgold, Andrews, Edwards, Smith, Saar, and Hammonds, all of whom used their art to make statements about the county's morality and its need to change.

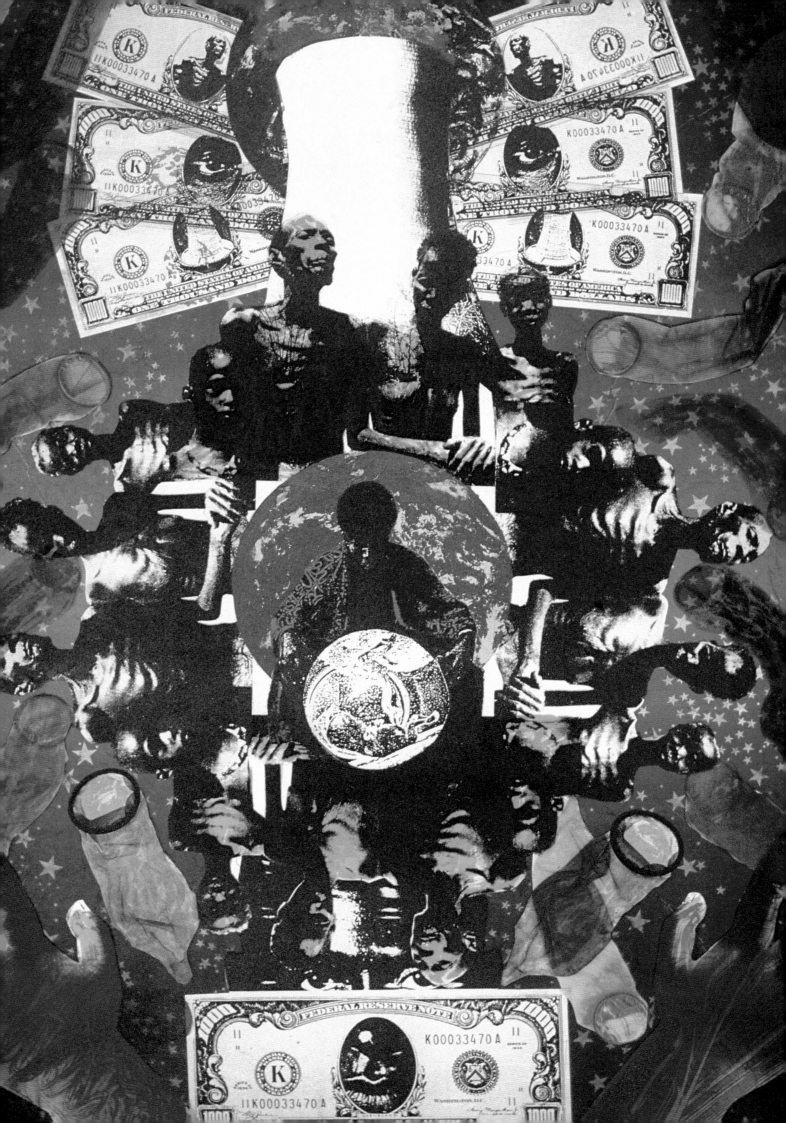

Monument to Malcolm X (#II)

BARBARA CHASE
RIBOUD (1936–)

1969; bronze and wool;
79⅛ x 42 x 16 in.
(200.9 x 106.6 x 40.6 cm).
Newark Museum, New Jersey.

After graduating from
Yale University in
1961 Riboud moved
to Europe, settling in
Paris and then Italy.
Her sculptures are
studies in opposites—
soft vs. hard, black
vs. white. Her use of
contrasting materials,
bronze and silk cording
or bronze and wood,
is an extension
of this exploration.

In 1969, when the Whitney mounted a survey exhibition of art from the 1930s and 1940s and failed to include a single Black artist, the BECC immediately picketed. In addition, the Studio Museum in Harlem countered by mounting an exhibition that celebrated African American artists from that same period, called *Invisible Americans: Black Artists of the '30s.*

Artists and arts organizations continued to stage a number of protests. Continuing their demonstration efforts, artists and arts organizations gathered at the Loeb Student Center at New York University on May 18, 1970, to protest the United States' invasion of Cambodia and the Kent State killings. New York Art Strike staged a sit-in where more than five hundred artists showed up on the steps of the Metropolitan Museum of Art. The Artworkers Coalition held an "open public hearing" at the School of Visual Arts, denouncing racial discrimination at the Museum of Modern Art, and solicited programs of reform.

So, when the Metropolitan Museum of Art mounted the *Harlem on My Mind: Cultural Capitol of Black America, 1900–1968* exhibition without the input of African American curators, the Black artistic community vigorously protested. And yet, the idea of challenging the Met on the opening night of the first and largest exhibition ever devoted to Black people in the history of North America was almost unthinkable. No one had ever questioned the exhibitions held at the Metropolitan Museum of Art.

Yet here they were, twisting and turning away from the cold edge of January's wind—Ed Taylor of the Harlem Cultural Council, BECC members Benny Andrews, Valerie Maynard, and Cliff Joseph, and many other individual artists and related groups. They all shivered and shuddered as they simultaneously pulled up coat collars and blew warm breath into cupped hands while stomping their feet on snow-covered cement, as if testing its strength. Their short and irregular movements mimicked those of cakewalkers in a winter performance as they stumbled and bumped into one another while measuring the distance between them. Their rhythm and pace evened out after one whole trek back and forth in front of the museum. And even though the wind was still chilling, it no longer blew, but was stilled.

The protest was against the way in which the exhibition had been organized, its content, exclusion of visual artists, and the implication that the exhibition, in total, represented the culture of Harlem. The exhibit not only inaccurately defined the culture of Harlem, but its design also reinforced the idea that Black people did not have any culture. This and other museum protests were about cultural control and inclusion. For a short while, these efforts wedged open the mainstream's door of exclusion.

The result was seen in the hiring of Black curators at the Metropolitan Museum of Art and the Museum of Modern Art. There also appeared an unprecedented number of Black exhibitions in American museums and related institutions. In 1971, the Museum of Modern Art presented one-man exhibitions by Romare Bearden and Richard Hunt. Moreover, *The Evolution of Afro-American Artists, 1800–1850*, organized by Dr. Caroll Greene and Romare Bearden, was shown at Gray Art Gallery, City College of New York; *30 Contemporary Black Artists*, organized by Ruder and Finn, was mounted at the Minneapolis Museum of Art; and *Five Famous Black Artists*, organized by Barry Gaither, was shown at the Museum of the National Center of Afro-American Artists, Boston.

With so dramatic an increase in the number of exhibitions of Black artists, and with the continuing visibility of activists, the Black Emergency Cultural Coalition was in an excellent position to make a series of demands upon the Whitney in New York. They pushed the museum to mount an all-Black exhibition and to hire and/or consult with Black scholars and curators. The Whitney responded with the exhibit *Contemporary Black Artists in America*. But it was mounted during its off season and without the input of Black scholars or curators. As a result, the BECC lobbied artists to withdraw their works from the Whitney exhibit; those withdrawn were then installed in a *Rebuttal to the Whitney* exhibition at the Acts of Art Gallery.

PROTESTING THE MALE ART ESTABLISHMENT

These demonstrations and protests, strikes, and counter-exhibitions served as strategic models for the women's movement, whose beginnings overlapped with that of the civil rights and Black Art movements. For instance, when Faith Ringgold, Lucy Lippard, and others picketed the Whitney Museum demanding more women be represented in their Annual, they were also simultaneously speaking out against the museum's exclusion of American artists who were of African descent. Bending in part to this pressure, the Whitney, for the first time, exhibited Black female artists Betye Saar and Barbara Chase-Riboud (1970).

Both an author and sculptor, Chase-Riboud began her training in the arts at an early age in Philadelphia, where she was born. Chase-Riboud won *Seventeen* magazine's art contest when she was fifteen years old,

and the Museum of Modern Art purchased the prize-winning print. She attended Yale, completing a MFA in architecture and design. Upon graduation in 1960, she went to London, then six months later to Paris, where she remained, married, and raised a family. She currently lives in Italy, while also maintaining residences in Paris and New York.

Her sculptures are architectonic in nature, and she tends to combine materials as a means of exploring opposite forces—soft/hard, male/female, negative/positive. Her 1972 *Malcolm X* series first introduces the combination of silk and wool cording to her bronze sculptures. Chase-Riboud, who published her first book of poetry in 1974, has also written several novels,

LOOKING INTO THE MIRROR, THE BLACK WOMAN ASKED, "MIRROR, MIRROR ON THE WALL, WHO'S THE FINEST OF THEM ALL?" THE MIRROR SAYS, "SNOW WHITE YOU BLACK BITCH, AND DON'T YOU FORGET IT!!!"

Mirror, Mirror

CARRIE MAE WEEMS (1953–)

1986–1987; photograph; 15½ x 15½ in. (39.3 x 39.3 cm).

The P.P.O.W. Gallery, New York.

Weems's photographic voice is brutal in its exploration of identity, particularly that of Black women. Her unique approach exposes stereotypes and chips away at the core of European-based beauty standards that, through secret subscription, confuse Black people in general and women in particular.

including *Sally Hemmings*, a controversial book about Thomas Jefferson and his Black slave/concubine, *Valide*, and *Portrait of a Nude Woman as Cleopatra*.

NEW ALTERNATIVES

Even though the Whitney's exhibits offered a few artists career opportunities, most Black artists didn't take the Whitney's efforts seriously. Indeed, Black artists "dubbed the [Whitney exhibition space] 'the nigger gallery' because of its small size and closeted location."[33] And its few exhibitions of Black women artists hardly began to address their large numbers seeking exhibition opportunities. They were between a rock and a hard place. White artists assumed that gender was not an issue affecting Black female artists, and that the shared racial heritage of Black men and women joined them in a mutual struggle that canceled their particular differences. Not only is this a convenient and pervasive myth in and outside the visual arts, but Bettina Aptheker rightly argues that Black women have had to "create their own destiny, and carve their own way through the sludge of a racist and sexist world and set their own standards of value and self-worth."[34]

The works of such artists as Clarissa Sligh, Carrie Mae Weems, Lorna Simpson, and Pat Ward Williams, to name a few, demonstrate the toll it has taken for women to do so. The language of their work is particularly open, uninhibited, and brutal. It deals with familial, societal, same- and opposite-sex relationships. Race myths and stereotypes about sex, power, and beauty are animated, deconstructed, accepted, altered, and denied. The viewer is given work to do and can linger or walk away; the choice is theirs, because in either case the issues don't dissolve or disappear.

The protests of the '60s and '70s spawned salt-and-pepper collaborations, out of which separate but equal community cultural and visual arts institutions, alternative groups, and organizations emerged. For instance, the DuSable Museum, Chicago, and the San Francisco African American Historical and Cultural Society, San Francisco, emerged in 1961. In 1962 Art West Associated was founded in San Francisco to promote African American art through exhibitions and art-related programs. They were followed by the Studio Museum in Harlem and the Anacostia Museum, Washington, DC, in 1967. In 1968 the Museum of the National Center of Afro-American Artists, Boston, was established, only to be followed by El Museo del Barrio, New York, and the Children's Art Carnival, New York, 1969.

The '70s and '80s saw the establishment of other Black and Hispanic art museums in New York, Washington, Dallas, Los Angeles, and South Carolina. These institutions interfaced with the pulse of popular culture, developed multiracial audiences, and became venues for the expression of the politics and aesthetics of Blacks, women, and (in the 1980s) homosexuals. America began to take notice of the bonding of increasing numbers of African, Latin, Native, and Asian American cultures, the commonality of their experiences despite their differences, and their collective strength as a political block. Traditional funding sources found themselves developing components solely devoted to funding the administrative and pro-

grammatic aspects of these institutions and groups. Many of them, now more than twenty years old, have grown into new-age warriors.

As autonomous visionaries of the 1990s, the rank and file of these institutions keep open the cultural floodgates and challenge the future reign of the colonialists and their sacred canon by providing another point of view through such exhibitions as *One With the Earth* (1973), organized by the Institute of American Indian Arts; *Two Centuries of Black American Art* (1976), organized by the Los Angeles County Museum, curated by David C. Driskell; Art of the Fantastic: Latin America, 1920–1987 (1987), curated by Holliday Day at the Indianapolis Museum of Art;

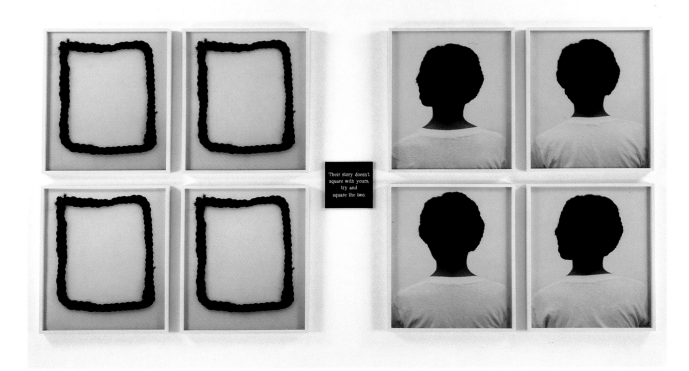

Guarded Conditions

LORNA SIMPSON (1960–)

1990; eight color Polaroid photographs with one plastic plaque;

52 x 105 in. (131X 266.7 cm.). Sean Kelly, New York.

Simpson's works—life-size color and black-and-white photographs—ask questions: Who am I? What am I doing? Is it authentic? Often addressed through a series of Black female images, they are answered through the positioning of the body, whose language tells the truth.

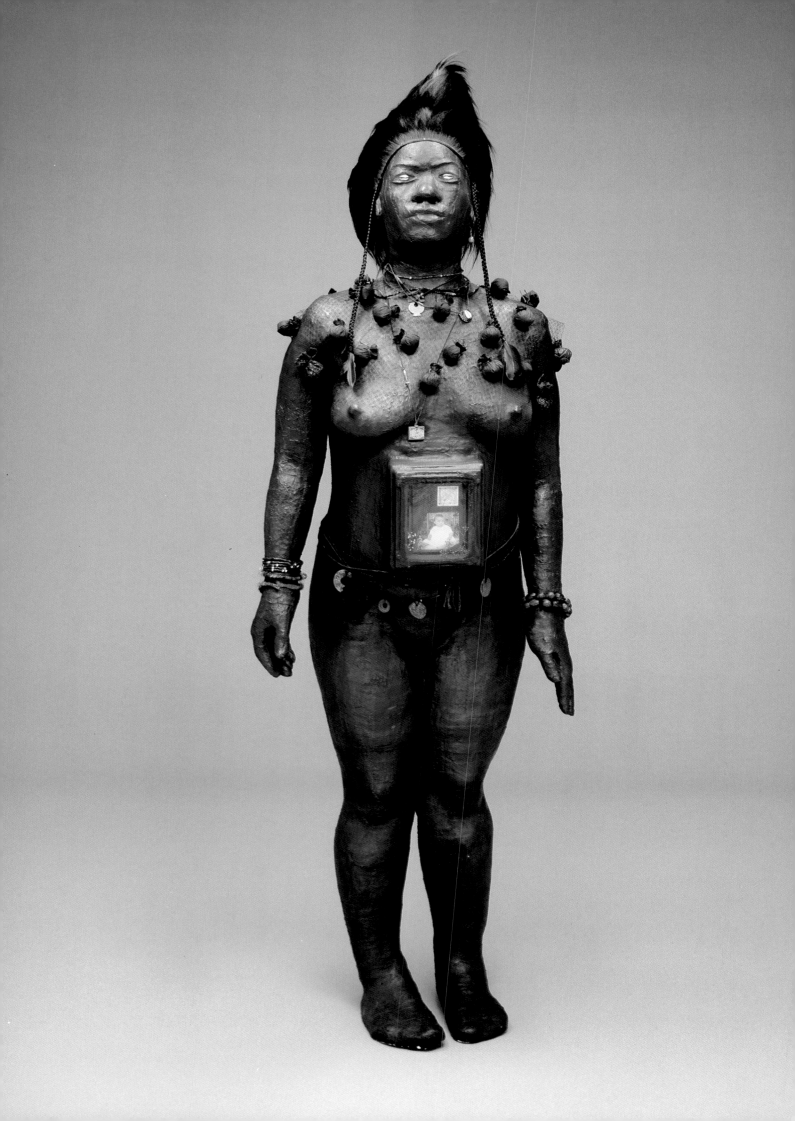

Coast to Coast: A Women of Color National Book Exhibition (1990), which opened at the Flossie Martin Gallery, Radford, Virginia; *David Wojnarowicz: Tongues of Flame* (1990), curated by Barry Blinderman, University Galleries, Illinois State University in Normal; and *Black Art—Ancestral Legacy* (1990), organized by the Dallas Museum of Art.

THE FUTURE OF BLACK ART

Despite the issues raised by these exhibitions and the traditions they reinforce, the question for the 1990s and the twenty-first century is whether society has made any substantive changes. Has, for instance, the presence of African and Latin American mayors and other such officials in high places anesthetized our critical vision of a society that has devoted a considerable amount of energy denying the existence of Blacks? Isn't this denial proof of an unreadiness to be educated about other people and other cultures? Isn't it also part of the confusion that surrounds multiculturalism on the one hand, and the relationship between the races and a still dominant culture, on the other? When attempts are made to deal with this racial and cultural denial, the dominant society resists and becomes further entrenched.

For example, when *Art as a Verb* (1988), a traveling exhibition organized by the Maryland Institute College of Art and curated by Leslie King-Hammond and Lowery Stokes Sims, first opened in Baltimore, Maryland, it included David Hammons' *How Do You Like Me Now*, a portrait/installation of Rev. Jesse Jackson in white-face accompanied by the American flag. Hammons' work stirred up a dialogue that made the dominant culture feel very insecure, particularly since more

Fetish #2

RENÉE STOUT (1958–)

1988; mixed media (plaster body cast); 64 in. high (162.5 cm).

Metropolitan Life Foundation Purchase Fund, Dallas Museum of Fine Art, Texas.

In this dramatic work Stout speaks to the collective values and richness of her African and Diasporic roots. She wrote in a 1995 exhibition catalog that "I felt like in creating that piece [*Fetish #2*], if I never created another one, I had created all that I needed to protect me for the rest of my life."

The Perception of Presence

CAROLE BYARD (1941–)

1992; earth, linen cloth, and wood, and recorded interviews. Courtesy of the Artist.

"My godson's experience stimulated this piece. He's grown up in Greenwich Village and one evening while out with his friends the police swooped down upon them. They were thrown against a fence, shoved and terrorized. Something that had happened in the subway. Talking with my godson, he told me, 'the taller I get the more people become afraid of me. Why do women clutch their bags . . . they know me . . . they know my mother.' "

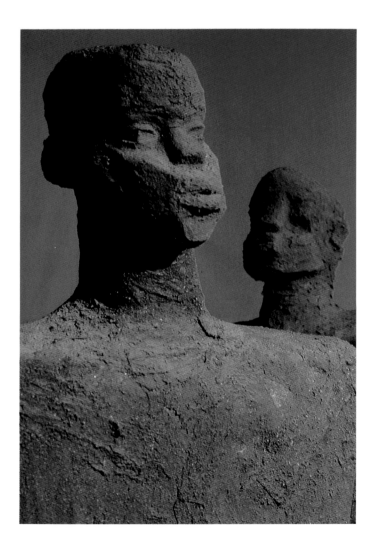

85

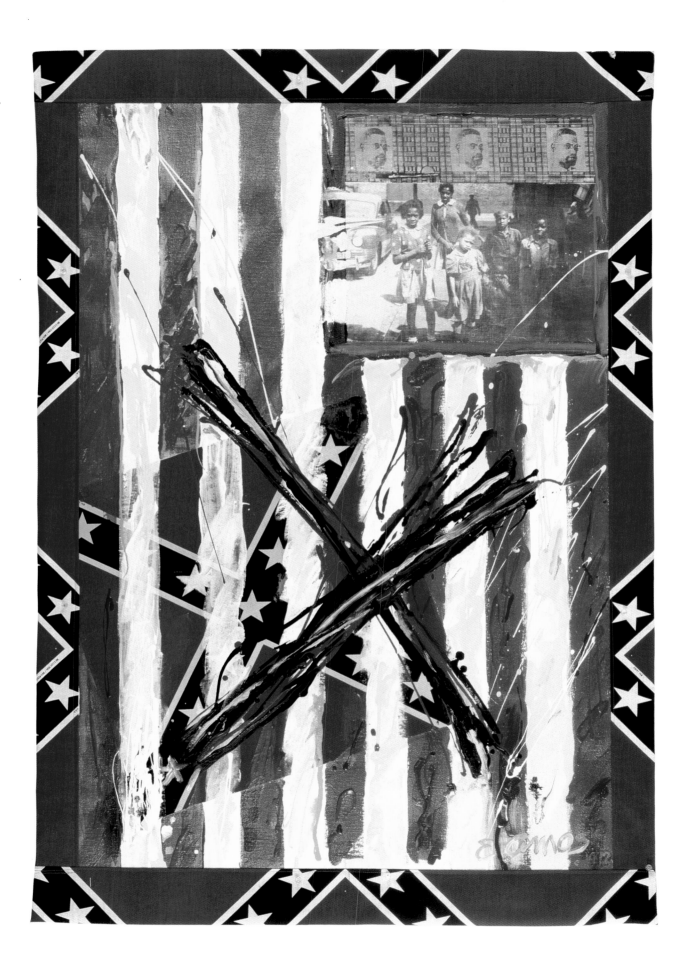

than one political pundit has suggested that if Jackson were White, he would have won his 1988 bid for the presidency of the United States. Rather than facing this idea, the sponsors censured Hammon and removed the piece from subsequent exhibition sites. The work had eloquently addressed the double standard African Americans are continually subjected to, a truth the exhibition funders found hard to bear. "Sadly," as Howardena Pindell points out, "Artists of color . . . are not permitted into the same mainstream to express their own feelings concerning race as counterparts to attacks on them and their identity . . . [and] institutions . . . are less tolerant of potent political images and ideas reflecting dissence."[35]

While this may be true, it has not prevented Black artists from continuing to express the realities of their American experience. Their art-making bears witness to both resistance and change. In some instances, such artists as Renée Stout, Grace Williams, and Willie Birch draw from an ancestral well that informs and guides the content of the work. They make magic, conjuring up a language that opens the door to the spiritualism in art. In other cases, artists such as Emma Amos, Carole Byard, Giza Daniels-Endisha, Marilyn Nance, and

Radcliff Bailey invent, create, and revise realities based in part on their personal, political, and historical realities.

Regardless of their influences, Black artists throughout the ages have been in pursuit of their individual aesthetic freedom. Its expression was candidly exposed in the recent *Black Male, Representations of Masculinity in Contemporary American Art* exhibition curated by Thelma Golden for the Whitney Museum of American Art. It was clear that the Black artists in this exhibition did not feel the need to look to the mainstream for acceptance or approval. All the better. For once the artist is free of this desire, the art stands as its own truth, becomes authentic and original to the maker. The language that subsequently emerges has its own identity and is reality-based. And though its message brings together the common experience of many, it also testifies to the cultural experience of being Black in America.

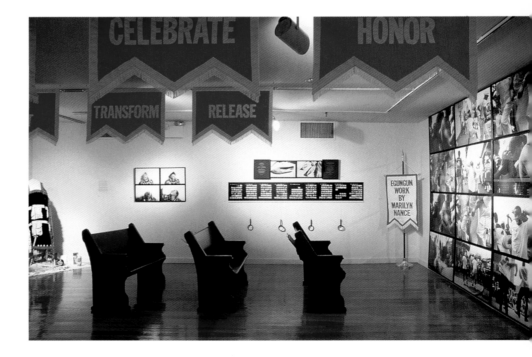

Spirit Faith Grace Rage

MARILYN NANCE (1953–)

1986–1996; photograph and story-telling, mixed-media installation. Courtesy of the Artist.

Since 1986 the artist has recorded culturally significant festivals, rituals, and sites. These photographs have led her to investigate the dynamic relationship between American and African culture with a particular emphasis on spirituality, the supernatural, family history, and the souls of Black men and women.

X Flag

EMMA AMOS (1938–)

1993; acrylic on linen canvas, laser transfer photograph, and Confederate flag borders, 58 x 40 in. (147.3 x 101.6 cm). Collection of Alice Zimmerman, courtesy of the Artist.

Amos invents images that are political, historical, and personal. Embodied with a magic realism, her works belie any marginality.

FOLLOWING PAGE:

Untitled

GRACE WILLIAMS (N.D.)

1990; mixed-media assemblage, front and back views. Photograph by Hugh Williams. Courtesy of the Artist.

The energy hovering over William's uninhibited, ceremonial, magical, and sensual work invokes sacred space. Carrying all the movement associated with dance, her works mime performance and demand action, but are stationary—powerful charms that empower the past and inform the present.

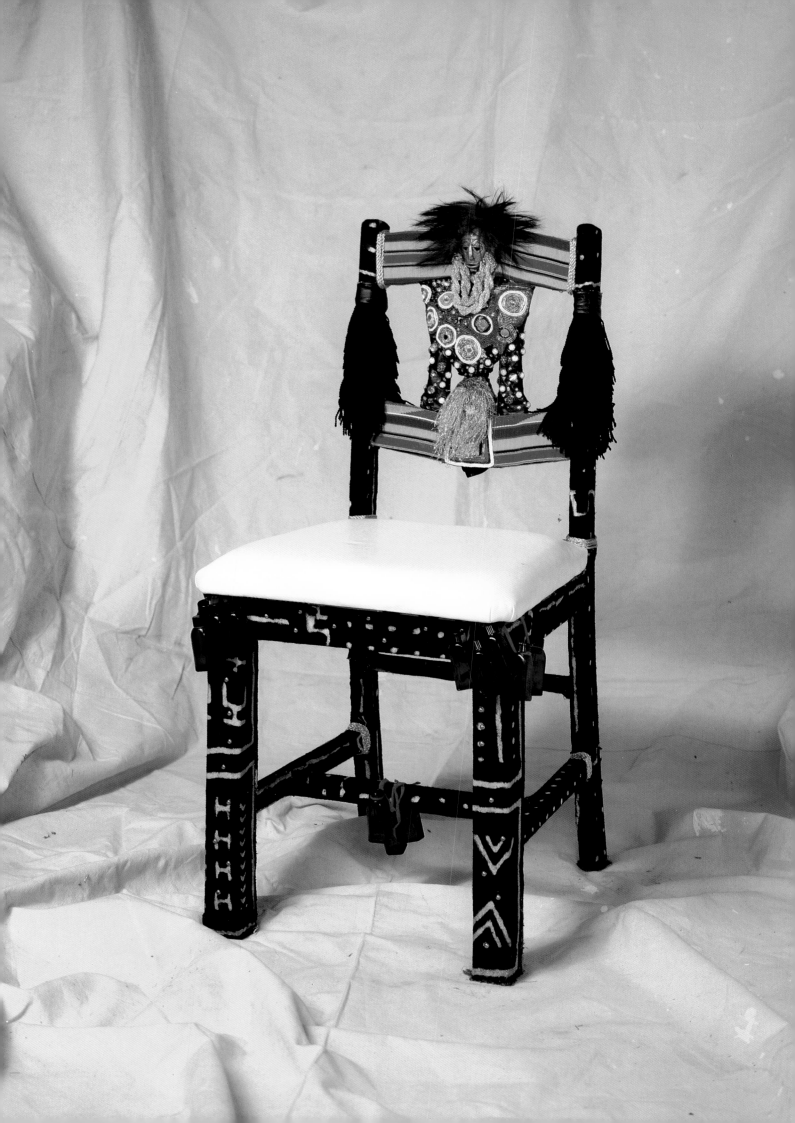

Little Men Series
VIVIAN BROWNE (1929–1993)

c. 1960s; oil on paper; 18 x 24 in. (45.7 x 60.9 cm).
Courtesy of Emma Amos.

Browne's landscapes and portraits blend realism and abstraction. Though her works are inspired by nature she can also speak in political terms, expressing the contradictions in men as power symbols.

Starry Crown
JOHN BIGGERS (1924–)

1987; acrylic on canvas; 59½ x 47½ in. (151.1 x 120.6 cm). Dallas Museum of Art, Texas.

Starry Crown, the name of a traditional spiritual, also refers to the headdresses of the women, crowns of their cultural glory. Early in his career Biggers traveled to Africa to study African tradition and culture. An artist and art-educator, he also supports the discipline by collecting African American art.

Design Made at Airlie Gardens

MINNIE EVANS (1892–1987)

1967; oil and mixed media on canvas; 19⅞ x 23⅞ in.
(50.5 x 60.6 cm). Gift of the Artist, National Gallery of
American Art, Smithsonian Institution, Washington, D. C.

"My whole life has been dreams, [and]
sometimes day visions . . . they would
take advantage of me. No one has taught
me about drawing. No one could because
no one knows what to teach me. No one
has taught me to paint; it came to me."

A Night in Tunisia

Keith Morrison (1942–)

1991; oil on canvas; 60 x 68 in. (152.4 x 172.7 cm). Courtesy of the Artist.

"Comedy is a distinct part of my work. Sometimes I simply amuse
myself; at other times the work is tragicomic. In any case, I have a
hard time taking the subject of my work very seriously. In my world
there is a lot of misery, but people laugh bitter-sweet at adversity. . . ."

Terra Firma

ALISON SAAR (1956–)

1991; wood, tin, tar & found objects; 24 x 74 x 22 in. (60.9 x 187.9 x 55.8 cm). Gift of the Friends of Contemporary Art and partial
purchase with 20th century deaccessioning funds in celebration of the museum's 50th anniversary, Santa Barbara Museum of Art, California.

Terra Firma derives its meaning from the metaphoric quality of the materials. The hard, dark, impenetrable quality of the wood exists in contrast to the lightness of the rusting ceiling tin which is shaped into trousers. When approached with the references of contemporary culture, the figure seems desperate, despairing, perhaps even dead.

Charm 2

MICHAEL KELLY WILLIAMS (1950–)

*1994; mixed-media, wood, thread, hair, Spanish moss, paper, cotton,
and sandpaper; 5 x 4 in. (12.7 x 10.1 cm). Courtesy of the Artist.*

"I have challenged myself by changing my method of working, my
means, scale and materials. I have . . . purged my art of its narrative
accouterments, condensing and strengthening the work . . . I find
the retention of African traits and techniques within the tradition
of African folk artists compelling, instructive and profound. I
have attempted to create new art from out of these meditations."

Zebra Crown

XENOBIA BAILEY (N.D.)

1996; aqua, orange, black, white, red, green, and yellow fiber
with cowry shells, beads, coins, and crochet. Courtesy of the Artist.

"I have created a contemporary art form called Ms. Xenobia
United Spirits of Africa which incorporates American crochet
with African arts of adornment. My purpose is to inspire
African Americans to culturally recreate themselves . . . [to]
spread this idea of cultural re-creation and personal adornment
. . . and have this way of being become a way of everyday life."

Baby Angel Doll Spirit #6

CHARNELLE HOLLOWAY (1957–)

1983; mixed media, repoussé & chasing (face)
dieforming (head); lost wax casting (hands and feet);
metals: copper, bronze or sterling silver. Hair is
hand-curled. Body parts are stuffed; clothes are
sewn for each dolls "aura"; 12.5 x 13.5 x 13.5 in.
(31.7 x 34.2 x 34.2 cm). Full view and detail.
Courtesy of the Artist.

In 1983 Holloway began creating
these small dolls, initially as part of
a toy project. She said of her work
that "The face [once completed] did
something to me. It wasn't just a doll
anymore. It had a mystical aura about
it—a spirit or an angel—that I didn't
know I was doing [in creating the work]."

Elysian Fields

ALMA W. THOMAS (1891–1978)

1973; acrylic on canvas; 30⅛ x 42⅛ in. (76.5 x 107.2 cm).

Bequest of Alma W. Thomas, National Museum of American Art,

Smithsonian Institution, Washington, D. C.

An artist-educator, Thomas did not devote full
time attention to her art until the age of seventy,
after her retirement from Shaw Junior High School
in Washington, D.C. She enjoyed a successful
career with exhibitions at the Whitney Museum
of American Art and the Corcoran Gallery.

Seer

MARTIN PURYEAR (1941–)

1984; painted wood and wire;

78 x 52½ x 45 in. (198.2 x 132.6 x 114.3 cm).

The Solomon R. Guggenheim Museum, New York.

Informed by African sources, Puryear's work
intersects at the crossroads of the fine art
and craft tradition. It celebrates an ancestral
tradition that in his hands—whether
creating a functional chair or an architectural
abstraction of a teepee—becomes modern art.

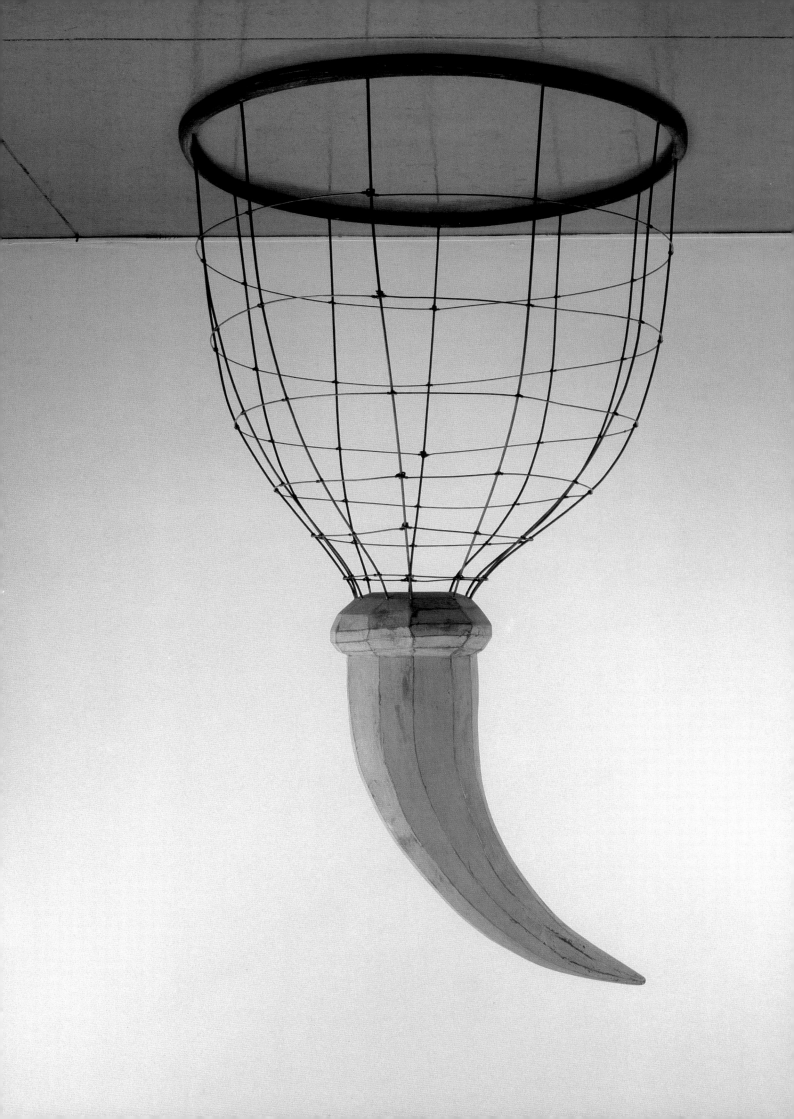

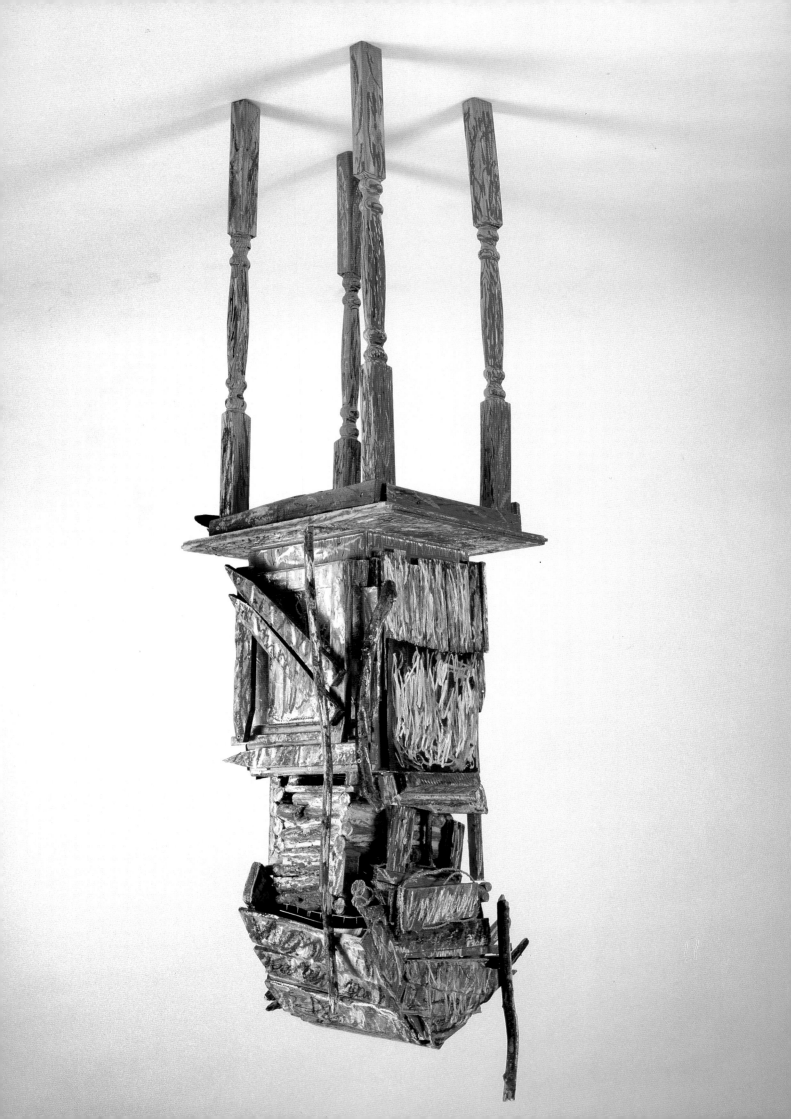

Untitled

CAMILLE BILLOPS (1933–)

1993; color etching; 18¼ x 24½ in.
(46.3 x 62.2 cm). Courtesy of the Artist.

"My art is reminiscent of a
day-to-day experience. I try to
use very private vehicles for
communicating with people . . .
Every creative, cultural and racial
experience has to do with my
work. I sift and look and taste."

Richard's Home

BEVERLY BUCHANAN (1940–)

1993; wood and mixed-media; 78½ x 22 x 21 in.
(199.3 x 55.8 x 53.3 cm). Photograph by Adam Reich.
Collection of Barbara and Eric Dobkin,
Steinbaum Krauss Gallery, New York.

The artist's paintings and/or drawings
serve as the backdrop for her shacks, which
are incarnated through the legends that in-
form the viewer about them and the occu-
pant's circumstances. These barren structures
seen alongside country roads or near
fields are reclaimed and no longer stand as
abandoned structures from a forgotten past.

FOLLOWING PAGE:

Number 45

LEONARDO DREW (1961–)

1995; fabric, feathers, rust, string/wood; 188 x 449 in.
(447.5 x 1140 4 cm). Mary Boone Gallery, New York.

From a distance, *Number 45* reads as a
non-objective landscape whose surface
has been built from layers of colorful paint
applied in dollops or stuck together to
create irregularities on the surface. However,
upon closer examination, one finds a
deception at play and instead a variety of
various found elements create the surface.
Things are never as they seem and the artist
aptly transfers this sensibility to the viewer.

P-Melon #1

JOYCE J. SCOTT (1948–)

1996; blown glass, beads, and thread; 13 x 20 x 10 in. (33 x 50.8 x 2.4 cm).

Photograph by Kanvi Takeno. Courtesy of the Artist.

Scott's work constantly challenges the viewer to consider
and reconsider reality. Her works, informed by West
African influences, are almost always narrative in nature.

Untitled

THOMAS HEATH (1949–)

1996; acrylic on canvas; 24 x 30 in. (60.9 x 76.2 cm). Courtesy of the Artist.

Heath began painting in 1989 at the age of forty. Rising early to go to
work as a taxi driver he would see the homeless bent over trash bins
looking for food. In the shallow morning light they looked like oblique
shapes and forms. Out of the blue, it came to him to try to draw them.

Vanilla Nightmares #8

ADRIAN PIPER (1948–)

*1986; charcoal on newspaper; 14 x 22 in.
(35.5 x 57 cm). The John Weber Gallery, New York.*

Piper's voice has always been investigative—she has used herself as an art object to amplify contradictions created by racism and sexism. Her drawings, performances, and video works mine areas outside of herself. She constantly has society on call, raising questions for its members to explore in an effort to seek personal honesty for purposes of transformation.

Fermament RHA (Vault of Heaven)

TERRY ADKINS (1953–)

Installation, including Ezekial, Osiris Age, Last Trumpet, *and* Relay Majestic. *Whitney Museum of American Art, New York.*

Here, the artist has paid homage to his father, Robert H. Adkins (1927–1995), and it is through this window of the particular that he has addressed the universal. The improvisational spirit, reincarnation, the journey of the soul—all create a whole experience that reveals itself in term of energy, not materiality.

**The New Ring
Shout, A Tribute
to the African
Burial Ground,
New York City**

HOUSTON CONWILL (1947–)

1995; installation. Courtesy Bernstein

Associates, Mt. Vernon, New York.

Conwill's works have always
explored the energy, power,
and spirit of place. Installations
dug into the earth sometimes
contain encrusted canisters,
the contents of which serve
as archeological maps to guide
us into and out of the past.

Current installations are
above-ground public-space
collaborations which deal
with the rituals associated
with place, its mythology,
and its meaning.

Maple Tree Series, Blue Eyed

SANA MUSASAMA (N.D.)

1996; installation. Courtesy of the Artist.

A flawless ceramist and sculptor, Musasama's works
excel in detail and precision. Her mastery over materials
has stimulated larger, more complicated works that are
sculptural in nature—they stand as silent sentinels surveying
expansive landscapes singularly and in group installations.

Untitled

GIZA DANIELS-ENDESHA (1962–1991)

c. 1980s; oil on heavy fabric, canvas; 77 x 50 in. (195.5 x 127 cm). Courtesy of Emma Amos.

"My artwork is a process of storytelling—bringing and invoking the past
and spirits and ancestors into people and environments. The society . . .
has created an environment of mistrust . . . Everyone has to conform
to pre-given ideals. When those ideals are exposed to be not the
truth, the artwork is not seen or appreciated for its truth in spirit."

Dry Bones (Fire from the Diaspora)

VINCENT D. SMITH (1929–)

1985; oil, sand, rope, and dry pigment. Courtesy of the Artist.

"The remarkable *Dry Bones (Fire From The Diaspora)* and
The Long Trek to Ouagadougou feature long strings of people, hand
in hand like paper dolls, extending off the edge of the canvas
symbolizing, alternately, shackling and the unity of mankind."

—VINCENT D. SMITH, *Rutgers University-Newark Campus*

Blackness

RADCLIFF BAILEY (1968–)

1995; acrylic and tar on wood; 60 x 60 x 4 in. (152.4 x 152. 4 x 10.1 cm). Courtesy of the Artist.

Bailey's work, like a spiritual divining rod, connects him to his ancestors. Serving
as stationary altars, the works house their souls. Although his photographic
family references are personal, in the collective picture-space their meaning is
universal, and speaks a language draped in the historical experience of America.

Three Cheers for the Red, White & Blue Quilt (Bessie)

AMALIA AMAKI (1949–)

1995; cyanotype on cotton and fabric;

64 x 56 in. (162.5 x 142.2 cm).

Courtesy of the Artist.

The blue is a metaphor for America—for the blues idiom, which is Americanizing the world. Bessie's flag is about how a mob prevented her from getting to a hospital before a White woman who was less seriously injured, and so Bessie bled to death. The flag is still bleeding.

Guarded Men

FRED WILSON (1954–)

1991; installation, four mannequins with museum guard uniforms; 75 x 48 x 166 in. (190.5 x 121.9 x 421. 6 cm). Courtesy of the Artist and Metro Pictures. Whitney Museum of American Art, New York.
From the ruins of modern day's material culture Wilson collects objects
to create installations. In this installation we find him making the
quintessential statement about Black men in the form of four headless
museum guards—invisible men inside and out of their workplace—or not.

The Monkey and the Pig

JAMES ANDREW BROWN (1953–)

1995; assemblage, gathering, paint, wood, and plastic; 4 x 7 in.
(10.1 x 17.7 cm). Photograph by Peter S. Jacobs. Courtesy of the Artist.

For the last three years the artist has been exploring the
theme of reversals, reversing the stereotypic imagery of
Black people and then expanding it to include other
cultures. While the work sometimes embraces a humorous
edge, it is deadly serious. His intent is to stir up conflict and
to explore the elements at war with one another in society.

Council of Convenience

JUAN LOGAN (1946–)

1995; acrylic on canvas; 60 x 48 in. (152.4 x 121.9 cm).
Courtesy of the June Kelly Gallery, New York.

Here, the artist blends elements of color
into shapes and forms to explore salvation
and the terms under which his winged
and hooded figure, manipulating a
marionette whose actions are predicated
under the guise of Christianity, delivers
it. His works have caused sufficient
distress to be vandalized and censored.

Shield of Memory I

ROBIN HOLDER (1952–)

1996; stencil monotype;

30 x 29¾ in. (76.2 x 75.7 cm).

Courtesy of the Artist.

The artist is dealing with the symbolism of the shield, which represents character, protection, and strength. The image of the ant is like a totem—describing certain traits and/or tendencies—and, here, symbolizing patience.

The semi-transparent woman is used to express personal memory and history vis à vis culture.

House on Treme

GILBERT FLETCHER (1948–)

1995; oil on canvas; 20 x 20 in. (50.8 x 50.8 cm). Courtesy of the Artist.

Although living in New York, Fletcher was born in New Orleans
and that is the subject of his work. The familiarity of the
painting and its accuracy offers up the intimacy of nostalgia.

Improvisation #5

BETTY BLAYTON-TAYLOR (1937–)

1977; monoprint; 23 x 30 in. (58.4 x 76.2 cm). Courtesy of the Artist.

Blayton-Taylor's artwork is coded in the metaphysical. The
sphere included in many of her works refers to wholeness,
the relationship between man and nature in the most ultimate
sense. Thus, her work serves as a gateway to higher spiritual levels.

African America
CHRISTOPHER WADE ROBINSON (1965–)

1993; mixed-media on canvas; 4 x 5 ft. (1.22 x 1.52 m). Courtesy of the Artist.

"I approach painting as an act of faith, a spontaneous
immersion into the waters of our being where the streams of
consciousness and those of external stimuli meet and blend in
our minds and hearts. Through painting we can illuminate
aspects of self, contained in the shadowy corners of our minds."

Untitled

MICHELLE GODWIN (1961–)

1993; monotype, mixed-media;

22 x 30 in (50.8 x 76.2 cm). Courtesy of the Artist.

"My prints use personal and sometimes universal symbols to address spiritual or political concerns in the hope of answering questions not always spoken but seen. In this work the artist is dealing with protection—how mothers protect their sons and how sometimes women protect men in ways they don't know."

Studies in Black, White and Silver # 19

FREDDIE STYLES (1944–)

1996; mixed-media monoprint; 14 x 17 in. (35.5 x 43. 1 cm). Courtesy of the Artist.

Styles' use of elements from nature as the source for the non-objective content in his work continues to produce exciting results. This current series transforms and amplifies the delicate veins of leaves and patterns from rocks into a series of intricate earth imprints.

NOTES

1. Crystal Britton, *Atlantic Memories: Middle Passage* (work in progress, 1996).

2. David C. Driskell, *Two Centuries of African American Art*, exhibition catalogue (New York: Alfred A. Knopf, 1976), 22–24.

3. Cleveland Museum of Art, *The Afro-American Tradition in the Decorative Arts*, exhibition catalogue (Cleveland, Ohio: Cleveland Museum of Art, 1978), 76–81.

4. National Museum of American Art, *Sharing Traditions, Five Black Artists in Nineteenth Century America*, exhibition catalogue (Washington, DC: Smithsonian Institutions Press, 1985), 39–48.

5. David C. Driskell, *Hidden Heritage: Afro-American Art, 1800–1950*, exhibition catalogue (Bellevue, Washington: Bellevue Art Museum, 1985), 13.

6. David C. Driskell, *Two Centuries of African American Art*, exhibition catalogue (New York: Alfred A. Knopf, 1976), 48–49.

7. Hope Franklin and John Franklin, *From Slavery to Freedom: A History of Negro Americans*, third edition (New York: Alfred A. Knopf, 1967): 215; and David C. Driskell, *Two Centuries of African American Art*, exhibition catalogue (New York: Alfred A. Knopf, 1976), 38–39.

8. The National Museum of American Art, *Sharing Traditions, Five Black Artists in Nineteenth Century America*, exhibition catalogue (Washington, DC: Smithsonian Institutions Press, 1985), 85–98.

9. Ibid.

10. Dewey F. Mosby, *Henry Ossawa Tanner*, exhibition catalogue (Philadelphia: Philadelphia Museum of Art, 1991.

11. Elizabeth C. Baker and Thomas B. Hess, eds., *Art and Sexual Politics* (New York: Collier Books, 1974), 43.

12. Samella Lewis, *Art: African American* (New York: Harcourt Brace Jovanovich, Inc., 1978), 54–55.

13. Mary Campbell Schmidt, David Driskell, David Lewis, and Deborah Willis, *Harlem Renaissance Art of Black America*, Studio Museum in Harlem exhibition catalogue (New York: Harry N. Abrams, Inc., 1987).

14. New Muse Community Museum of Brooklyn, *The Black Artists in the WPA 1933–1943*, exhibition catalogue (Brooklyn, New York: New Muse Community Museum of Brooklyn, 1976), 20.

15. Ruth Ann Stewart, guest curator, *New York/Chicago WPA and The Black Artist*, exhibition catalogue (New York: Studio Museum in Harlem, 1978).

16. National Black Arts Festival, *Selected Essays: Art & Artists From the Harlem Renaissance to the 1980s*, exhibition catalogue (Atlanta, Georgia: National Black Arts Festival, Inc., 1988), 24–26.

17. Albany Institute of History and Art, *The Negro Artist Comes of Age*, exhibition catalogue (Albany, New York: Albany Institute of History and Art, 1945).

18. Elsa Fine Honig, *The Afro-American Artist* (New York: Holt, Rhinehart, and Winston, 1973), 154.

19. Ibid., 156.

20. Elton Fax, *17 Black Artists* (New York: Dodd, Mead, 1971), 29; and Samella Lewis, Art: African American (New York: Harcourt Brace Jovanovich, Inc., 1978), 125.

21. Edgar B. Gumbert, ed., *Different People: Studies in Ethnicity and Education* (Atlanta, Georgia: Center for Cross-Cultural Education, College of Education, Georgia State University, 1983), 13, 19.

22. *Essays on Women's Art* (New York: E.P. Dutton, 1976), 259.

23. Elsa Fine Honig, *The Afro-American Artist* (New York: Holt, Rhinehart, and Winston, 1973), 209.

24. Randy Rosen, "Moving into the Mainstream," *Making Their Mark: Women Artists Move into the Mainstream, 1970–85*, exhibition catalogue (New York: Abbeville Press, 1989), 10.

25. Studio Museum in Harlem, *Tradition and Conflict, Images of a Turbulent Decade, 1963–1973*, exhibition catalogue (New York: Studio Museum in Harlem, 54.

26. Lucy Lippard, *Mixed Blessings, New Art in a Multicultural America* (New York: Pantheon Books, 73.

27. Samella Lewis, *Art: African American* (New York: Harcourt Brace Jovanovich, Inc., 1978), 152.

28. Ibid. p. 173.

29. Montclair Art Museum, *The Afro-American Artist in the Age of Pluralism*, exhibition catalogue (Montclair, New Jersey: Montclair Art Museum, 1987), 13.

30. *Choosing: An Exhibit of Changing Perspectives in Modern Art and Art Criticism by Black Americans, 1925–1985*, exhibition catalogue (Washington, DC: Museum Press, 55.

31. Lewis, Samella, *Art: African American* (New York: Harcourt Brace Jovanovich, Inc., 1978), 110.

32. Studio Museum in Harlem, *Tradition and Conflict, Images of a Turbulent Decade, 1963–1973*, exhibition catalogue (New York: Studio Museum in Harlem), 78.

33. Ibid., 56.

34. Bettina Aptheker, *Tapestries of Life, Women's Work, Women's Consciousness, and the Meaning of Daily Experience*.

35. Howardena Pindell, "Breaking the Silence," part II, *NewArt Examiner*, vol. 18, no. 3 (1990): 24.

Untitled Mask

LLOYD TOONE (N.D.)

1987; mixed media, leather, wood, nails, pigment. Courtesy of the Artist.

Toone who emerged in the 1960s, like many other artists, became an artist-educator and devoted much of his career teaching art education. Both a sculptor and painter, Toone explores African American folklore and culture through his art. In his sculpture, he looks to Africa as an influence and uses found objects and woods.

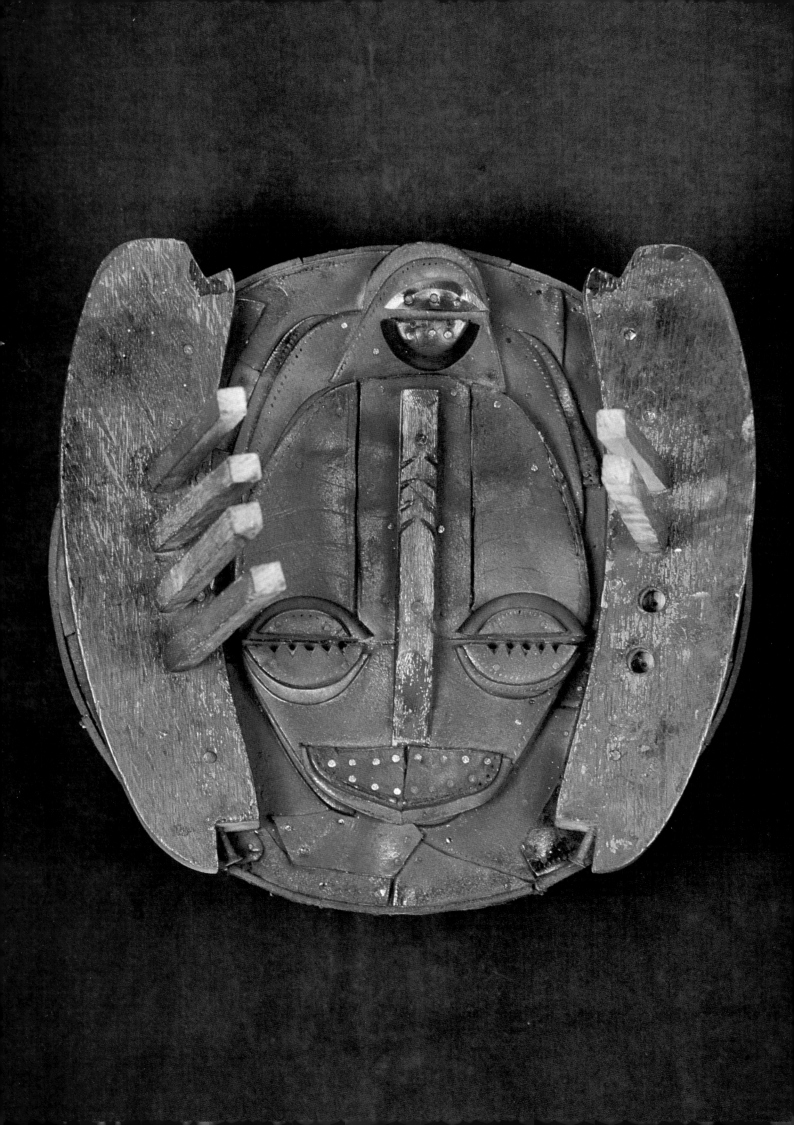

INDEX

Page numbers in **bold-face** type indicate photo captions.

Aden, Alonzo, 58
Adkins, Terry, *Fermament RHA (Vault of Heaven)*, **108–9**
African American art, 4–14; African roots of, 19–21;
 exhibitions of, 58–59, 81, 87; future of, 85–87; nature of,
 67–68; racial subject matter, 32, 39, 42–45
African American artists: earliest identified artists, 21–32;
 exhibition opportunities, 14, 46–48, 78–85; role of,
 debate, 12, 14, 59, 67–68; sources of support for, 12–13,
 46–54, 67; training of, 26, 29; travels abroad, 37
African Americans: associations, 4–7, 12, 42; employment,
 50; images of, in White art, 37; middle class, 7, 13, 42;
 and racism, 4–7, 27, 50
African American women artists: art training of, 37–41;
 exhibition opportunities, 48, 71, 81–82; inclusion efforts,
 14; recognition of, historically, 31
African art, links with African American art, 4, 19–21, 45
African Commune for Bad Relevant Artists (AFRI-COBRA),
 14, 77
Africanisms, 19
Alston, Charles, 68; *Family Group*, **6–7**
Amaki, Amalia, *Three Cheers for the Red, White & Blue Quilt
 (Bessie)*, **116**
American flag, in protest art, 71
American Scene movement, 42
Amos, Emma, 67, 87; *X Flag*, **86–87**
Anacostia Museum, 82
Andrews, Benny, 78, 81; *Latter Day Saint Sebastian* (Cruelty
 and Sorrow Series), **78**
art establishment, 78–81
art for art's sake, 12
Artis, William E., 54; *Head of a Boy*, **42–43**
artist coalitions, 13–14
Art of the American Negro (1850–1940) (Chicago), 58
arts programs, community-based, 54
Art West Associated, 82
Artworkers Coalition, 81
Atlanta University System, 54, 59

Bailey, Radcliff, 87; *Blackness*, **115**
Bailey, Xenobia, *Zebra Crown*, **97**
Ball, James P., 29
Bannister, Edward Mitchell, 28; *Moon over a Harbor*, **28**
Barnett Aden Gallery, 58, 59
Barthé, Richmond, 48; *Julius*, **48**
Basquiat, Jean-Michel, *Hollywood Africans—1940*, **16–17**
Bearden, Romare, 67–68, 70; *The Living Room*, **66**
Biggers, John, *Starry Crown*, **90–91**
Billops, Camille, *Untitled*, **103**
Birch, Willie, 70, 87; *Oppression Anywhere is Oppression
 Everywhere*, **70**
Black Movement, 70–71, 77–78
Blackburn, Bob, 68; *Heavy Forms*, **68**
Black Emergency Cultural Coalition (BECC), 78–81
Blayton-Taylor, Betty, *Improvisation #5*, **122–23**
Bowser, David Bustille, 27; *The Bald Eagle and the Shield of
 the United States*, **27**
Brown, Grafton Tyler, *Yosemite Falls*, **22**
Brown, James Andrew, *The Monkey and the Pig*, **118**
Brown, Kay, 71
Browne, Vivian, *Little Men Series*, **90**
Buchanan, Beverly, *Richard's Home*, **102–3**
building and building trades, 20–21
Burke, Selma, *Peace*, **12**
Burroughs, Margaret, 54
Byard, Carole, 87; *The Perception of Presence*, **85**

Catlett, Elizabeth, 68–70; *Tired*, **68–69**
ceramics, 21–26
Chandler, Dana, 77–78
Chase-Riboud, Barbara, 81–82
Children's Art Carnival, 82
civil rights movement, 13–14, 59, 67
Civil War era, 26–32
Clark, Ed, 67
Colescott, Robert, *Knowledge of the Past is the Key to the
 Future*, **15**
colonial America, 4, 19–21
Commission on Interracial Cooperation, 42
Conwill, Houston, *The New Ring Shout, A Tribute to the
 African Burial Ground, New York City*, **110–11**
Cortor, Eldzier, 58; *Southern Gate*, **59**
Cox, Renée, *It Shall be Named*, **16**
crafts, 20, 27
The Crisis (magazine), 46
Critchlow, Ernest, 68
Crite, Allan Rohan, *Harriett and Leon*, **37**

Daniels-Endesha, Giza, 87; *Untitled*, **113**
Dave the Potter, 21–26; *jar*, **21**

Day, Thomas, 21; newel post, **20**; *Rocking Chairs*, **19**
decorative arts, 20
Delaney, Beauford, 48, 67, 68; *The Burning Bush*, **50–51**
Delaney, Joseph, 52
Donaldson, Jeff, 77
Douglas, Aaron, 39, 45, 52, 53, 68; *The Creation*, **44–45**
Drew, Leonardo, *Number 45*, **103–5**
DuBois, W. E. B., 42
Duncanson, Robert Scott, 28, 29–31; *The Blue Hole, Flood
 Waters, Little Miami River*, **23–25**
DuSable Museum, 82

Eakins, Thomas, 32, 37
Edmonson, William, *Eve*, **10–11**
Edwards, Mel, 77; *Fire Blossom*, **76–77**
El Museo del Barrio, 82
European aesthetic, rejection of, 12
Evans, Minnie, *Design Made at Airlie Gardens*, **92**

Farrow, William McKnight, 46; *Old Oaken Bucket*, **46**
Federal Arts Project (FAP), 13, 53, 54
Fletcher, Gilbert, *House on Treme*, **123**
Forman, James, *Game Table*, **7**
Fuller, Meta Vaux Warrick, 37, 39–41, 46; *The Awakening of
 Ethiopia*, **39**
furniture, 21

Garvey, Marcus, 7, 42, 45
Godwin, Michelle, *Untitled*, **125**
Great Depression, 12–13, 50–54
Great Migration, 4

Hammons, David, 74–77, 85–87; *Injustice Case*, **74**
Harlem, 4, 42, 50
Harlem Artists Guild, 53, 68
Harlem Community Art Center, 54
Harlem Renaissance, 12, 13, 39, 41–46
Harleston, Edwin, 45, 46
Harmon, William E., 12
Harmon Foundation, 12, 46–48, 67, 68
Harper, William A., *Landscape with Poplars (Afternoon at
 Montigny)*, **18**
Hayden, Palmer, 39, 45, 46, 48; *Big Bend Tunnel* from the
 Ballad of John Henry Series, **60**
Heath, Thomas, *Untitled*, **107**
Hendricks, Jon, 71
Holder, Robin, *Shield of Memory I*, **120–21**
Holloway, Charnelle, *Baby Angel Doll Spirit #6*, **98–99**
Howard University, 54, 59
Hudson River School, 29

Jackson, May Howard, 37, 39
Jarrell, Wadsworth, 77
Johnson, Malvin Gray, 48; *The Old Mill*, **40–41**
Johnson, Sargent, 48, 52
Johnson, William Henry, 39, 45, 48; *House by the Hill*, **36**
Johnston, Joshua, 26; *The Westwood Children*, **23**
Jones, Barbara, 77
Jones, Lois Mailou, 48, 58; *Ubi Girl from Tai Region*, **48–49**
Jones, Napoleon Henderson, 77
Joseph, Cliff, 78, 81

Karamu House, 54
Key, Vivian Schuyler, cover for *The Crisis*, **46–47**

Lawrence, Carolyn, 77
Lawrence, Jacob, 58, 67, 68; *The Migration of the Negro*, **62**
Lee-Smith, Hughie, 58; *Reflections*, **56–57**
Lewis, Edmonia Wildfire, 28, 31–32, 37; *Fovever Free*, **30–31**
Lewis, Norman, 67–68, 70; *Harlem Turns White*, **42**
Lippard, Lucy, 81
Locke, Alain, 12, 42, 45, 59
Logan, Juan, *Council of Convenience*, **118–19**

Maynard, Valerie, 78, 81; *Send the Message Clearly*, **78–79**
McCannon, Dingda, 71
Metropolitan Museum of Art, 78, 81
Middleton, Sam, 67
mixed media, 74–77
Moorehead, Scipio, 26; *Phyllis Wheatley*, **26**
Morrison, Keith, *A Night in Tunisia*, **93**
Motley, Archibald John, Jr., 52; *Mending Socks*, **52**
murals, 77–78
Musamama, Sana, *Maple Tree Series, Blue Eyed*, **112**
Museum of Modern Art, 78, 81
Museum of the National Center of Afro-American Artists, 82
museums, 14, 78–85; of Black Art, 82–85

NAACP, 4, 42
Nance, Marilyn, 87; *Spirit Faith Grace Rage*, **87**
New Deal, 50–54

New Negro Movement, 12, 42
New York Art Strike, 81
135th Street YWCA (N.Y.C.), 54
Organization of Black Cultures, 14

Parks, Gordon, 54
Perkins, Marion, *The Kiss*, **61**
photography, 45–46
Pindell, Howardena, 87; *Autobiography: Water/Ancestors,
 Middle Passage/Family Ghosts*, **14**
Piper, Adrian, *Vanilla Nightmares*, **109**
Pippin, Horace, *John Brown Going to His Hanging* (from the
 John Brown Series), **11**
Porter, James A., 48; *Woman Holding a Jug*, **13**
portraiture, 26
Powers, Harriet, *Bible Quilt*, **8–9**
Prophet, Nancy Elizabeth, 48; *Silence*, **29**
Public Works of Art Project (PWAP), 12, 52
Puryear, Martin, *Seer*, **100–101**

Reason, Patrick, 27, 32
Regionalism, 7, 12, 42
Reiss, Winold, 45
Riboud, Barbara Chase, *Monument to Malcolm X (#II)*, **80**
Rickson, Gary, 77
Ringgold, Faith, 71–74, 81; *Flag for the Moon: Die Nigger*, **72–73**
Robinson, Christopher Wade, *African America*, **124**
Roosevelt H.S. (Gary, Ind.), 54

Saar, Alison, *Terra Firma*, **94–95**
Saar, Betye, 77, 81; *The Liberation of Aunt Jemimah*, **74–75**
San Francisco African American Historical and Cultural
 Society, 82
Saunders, Raymond, 70; *Jack Johnson*, **71**
Savage, Augusta, 48, 52, 53, 54, 68; *Gamin*, **53**
Schomburg, Arthur, 46
Scott, Joyce J., *P-Melon #1*, **106**
Scott, William Edouard, *Night Turtle Fishing in Haiti*, **34–35**
Sebree, Charles, 54; *The Blue Jacket*, **54–55**
shotgun house, 20–21
Simpson, Lorna, 82; *Guarded Conditions*, **83**
Simpson, William, 32
slavery era, 19–32
Sligh, Clarissa, 82
Smith, Frank, 77
Smith, Vincent D., *Dry Bones (Fire from the Diaspora)*, **114**
Social Realism, 7, 12, 42–45
South Side Community Art Center (Chicago), 54
Spiral, 14, 67–68, 71
Stevens, Nelson, 77
Stout, Renée, 87; *Fetish #2*, **84–85**
Students and Artists for Black Art Liberation (SABAL), 71
Studio Museum in Harlem, 71, 81, 82
Styles, Freddie, *Studies in Black, White and Silver #19*, **126**

Tanner, Henry Ossawa, 28, 32, 37; *The Banjo Lesson*, **32–33**
Taylor, Ed, 81
Thomas, Alma W., *Elysian Fields*, **100**
306 Group, 68
Toche, Jean, 71
Toone, Lloyd, *Untitled Mask*, **126–27**
Traylor, Bill, *Man and Large Dog*, **35**
Treasury Department, Section of Painting and Sculpture,
 12–13, 53

Universal Negro Improvement Association, 7, 42, 45
Unknown artist, *Figure Holding Vessel*, **4–5**

Van Der Zee, James, 39, 45–46
The Vanguard (club), 53

Walker, Annie E., 37
Walker, William, 77
Wall of Dignity, 77–78
Wall of Respect, 77
Waring, Laura Wheeler, 37, 39; *Anne Washington Derry*,
 38–39
Weems, Carrie Mae, 82; *Mirror, Mirror*, **82**
Wells, James Lesesne, 46; *The Flight into Egypt*, **58**
Where We At Black Women, 71
White, Charles, 54, 70; *Wanted Poster Number 4 (Sara)*, **54**
Whitney Museum, 78, 81, 82, 87
Williams, Grace, 87; *Untitled* (two works), **87–89**
Williams, Michael Kelly, *Charm 2*, **96**
Williams, Pat Ward, 82; *What You Lookn At*, **15**
Williams, William T., 67
Wilson, Ellis, *Field Workers*, **64**
Wilson, Fred, *Guarded Men*, **117**
Woodruff, Hale, 48, 52–53, 54; *A Celestial Gate*, **64–65**
Works Progress Administration (WPA), 13, 52–53, 67